NEWBY & SCALBY

including Scalby Mills

THROUGH TIME

Robin Lidster

AMBERLEY PUBLISHING

Acknowledgements

I would like to thank the following people and organisations for their help, advice, or use of photographs – Bill Atkinson; Alan Brown; Frank & Heather Dean; John & Sandra Dudley; Debbie Edwards, Alison and Henrietta; Revd Alastair Ferneley; Steve Johnson; Stuart Leslie; Radd McLachlan; Max Payne MBE; Colin Spink (Antiques & Collectors Centre, Scarborough); Frank & Kath Thompson; Athol Wallis; also Barbara Hatton, Rosie, Joy, Pat, Lou and Keeley (for the most colourful photograph in the book!); and the friendly residents of the parish that I met while roaming the streets to take the recent photographs. Many thanks also to the helpful staff at Scalby Library who provide a valuable and much-appreciated service to the local community.

*This book is dedicated to my wife Val for all her patience and support,
and to celebrate our ruby wedding anniversary!*

In the same series by Robin Lidster: *Robin Hood's Bay & Fylingthorpe Through Time,
Scarborough & Whitby Railway Through Time, Burniston to Ravenscar Through Time*

Front Cover Images: Scalby Mills has been a popular resort for visitors for about two hundred years; in 1840, a Mrs Dale is recorded as having the tea garden at Scalby Mill, providing refreshments for tourists and local people. Later, various forms of entertainment were provided, including donkey rides and musicians. The present Old Scalby Mills continues the long tradition of refreshment into the twenty-first century.

First published 2011

Amberley Publishing
The Hill, Stroud
Gloucestershire, GL5 4ER

www.amberley-books.com

Copyright © Robin Lidster, 2011

The right of Robin Lidster to be identified as the
Author of this work has been asserted in accordance
with the Copyrights, Designs and Patents Act 1988.

ISBN 978 1 84868 670 0

British Library Cataloguing in Publication Data.
A catalogue record for this book is available from
the British Library.

Typeset in 9.5pt on 12pt Celeste.
Typesetting by Amberley Publishing.
Printed in the UK.

Introduction

The opinion of most historical and travel writers in the eighteenth and nineteenth centuries was that Scalby was 'a place of great antiquity' and 'a pretty village'. One guide book went so far as to say that it was 'in its general appearance more inviting than many other villages of the county; it being agreeably dispersed; not having too much of a straight line, but presenting many rural deviations, both as regards the buildings themselves and their situation.'

The *Scarborough & Whitby Railway Official Guide* of 1897 introduced the visitor to Scalby (the location of the first station on its line): 'Situated in the midst of a rich pastoral country through which runs Scalby Beck (an excellent trout stream) this place is yearly becoming more popular as a place of residence and resort. Suffield Hill rises towards the west; and in the south-west are the Raincliffe Woods, extending for several miles. In spring, summer and autumn these latter, as viewed from Scalby, present a remarkably fine appearance. The Church of St. Lawrence, situated on an eminence towards the west of the village, and in the centre of an old-time churchyard, is singularly picturesque.'

The Church of St Laurence, like many village churches, is the oldest surviving building in the parish and some features of its architecture, notably the chancel arch and the nave arcades, date back to about the year 1180. There are many fascinating features, and some mysteries, in this church, and it is cherished and well attended by members of the local community where over a hundred people gather every Sunday. It is also worth a visit by anyone who seeks peace and friendship in beautiful surroundings where the residents of Scalby have been worshipping for over 800 years.

The heart of Scalby village still remains, visually, much as it was about 100 years ago, but over the last few years it has seen considerable residential developments to the north and east. It is largely due to the efforts of the Scalby Village Trust that the villages of Newby and Scalby still retain their separate identities by the maintenance of an albeit narrowing green belt along the sides of Scalby Beck and The Cut. Their work includes continuous scrutiny of planning applications affecting buildings and land within the parish to maintain the integrity of the old villages, as far as possible.

Many old photographs survive, illustrating the Parish of Scalby from about 1890 to about 1940, and a varied selection are presented here, together with recent photographs, to illustrate how many of the streets and some of the buildings have changed in the last one hundred years. In addition, some of the photographs show aspects of life in the village that have changed or disappeared largely in response to mechanisation. Brief historical details are provided and the author hopes this will provide a stimulus to further interest through the world-wide web, the books listed in the Bibliography and, not least, in local libraries.

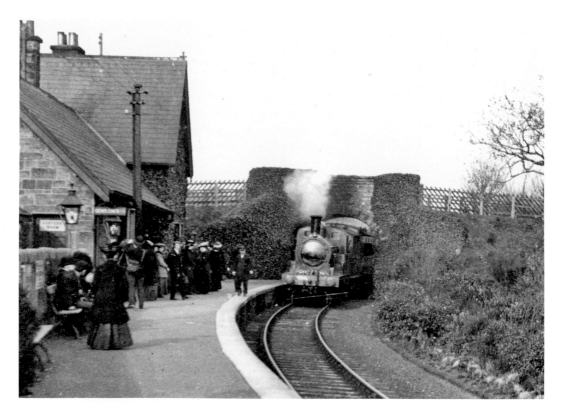

Scalby Station: A Catalyst for Change

The opening of the Scarborough & Whitby Railway in 1885 stimulated the growth and expansion of Scalby village. Scalby station not only expedited faster travel facilities for the new business and wealthier residents from the 1890s onwards, it also provided the facility to import the building materials and equipment for their new villa residences (see pages 72–81).

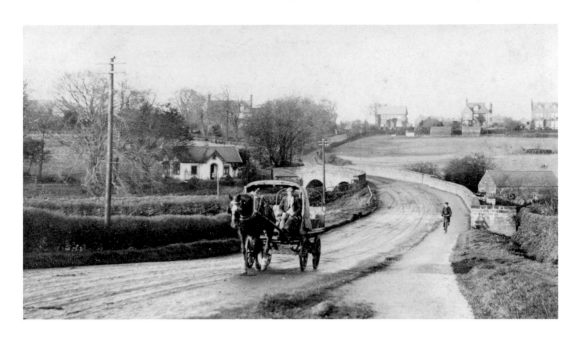

Newby Bridge: A Bygone Age

Newby Bridge stands on the boundary between the villages of Newby and Scalby. On the left is The Lodge, formerly a gatehouse for Scalby Hall (see page 49). Below a detail from a similar photograph shows a waggonette pausing to be photographed in the middle of Scalby Road, not advisable on the present A171! The bridge now carries the main Scarborough–Whitby road over Scalby Beck, and is a central point from which to start a tour round the streets and lanes of the area. The illustrations in this book are arranged in a more or less topographical order ending at Scalby Mills.

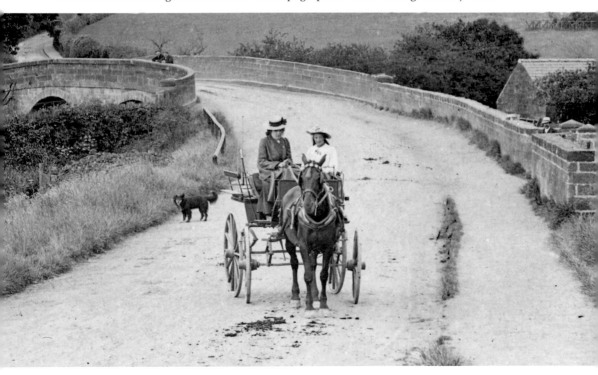

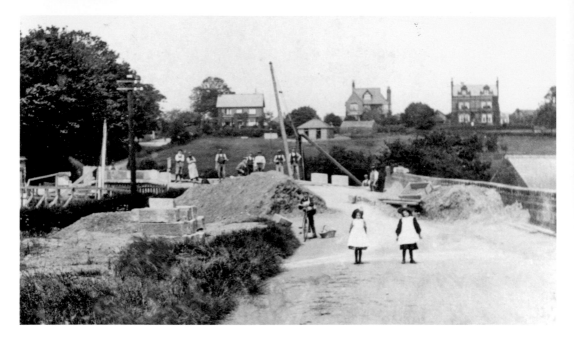

Rebuilding Newby Bridge: Posing for the Camera

In order to accommodate increasing road traffic, Newby Bridge was rebuilt in 1906/07 at a cost of about £900, and these photographs show the view from Scalby Road (above) and from the downstream side (below). The appearance of a photographer seems to have brought a halt to all activity, including that of the children and the cyclist. A total of about sixteen men appear to be working on the reconstruction of the bridge, which was widened and included the provision of a footpath on one side.

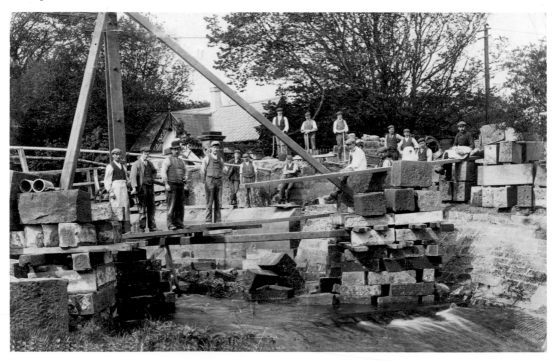

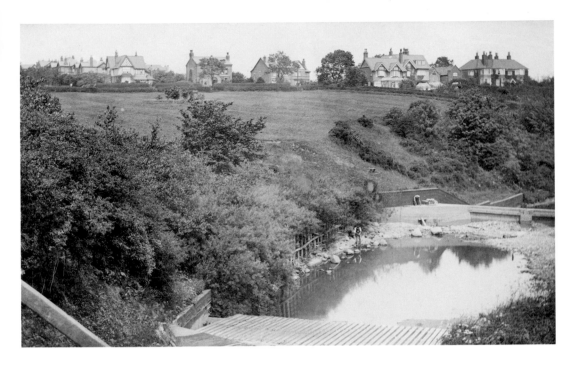

Newby Bridge: The Downstream Side

Prior to about 1800, Scalby Beck was crossed by means of a ford and a footbridge. The New Cut, as it was called, was built from here, upstream, to the River Derwent at Mowthorpe in about 1804 in response to severe flooding in the Vale of Pickering in 1799. It provided a means of diverting excess water down the original Scalby Beck from here to Scalby Mills. Before the bridge was rebuilt in the 1950s, the old bridge spanned the gap in the foreground in the recent photograph.

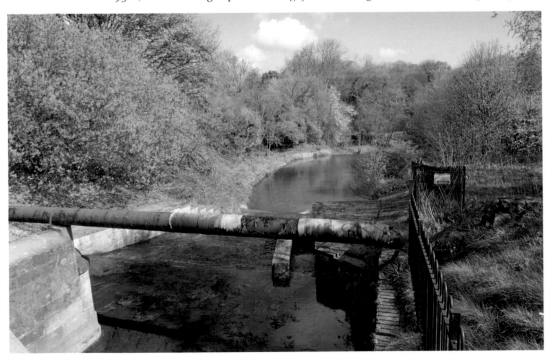

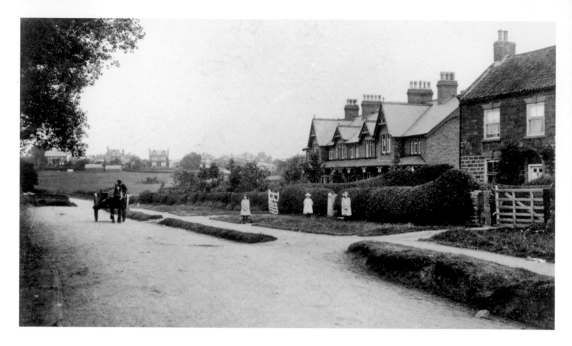

Scalby Road, Newby

The peaceful nature of Scalby Road can be seen in the old photograph when the only traffic was the occasional horse-drawn cart, conveying local traffic, and the odd bicycle or two. The road is now part of the A171, carrying traffic to and from Whitby, Middlesbrough and beyond, with frequent heavy lorries delivering tons of supplies to the local supermarkets, or to and from Hull Docks. Another contrast in many of these photographs is the number of trees by the roadsides.

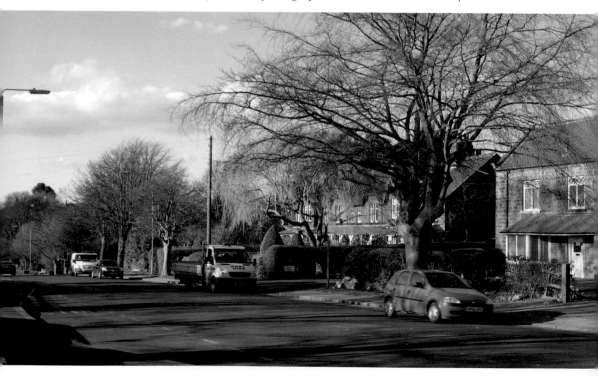

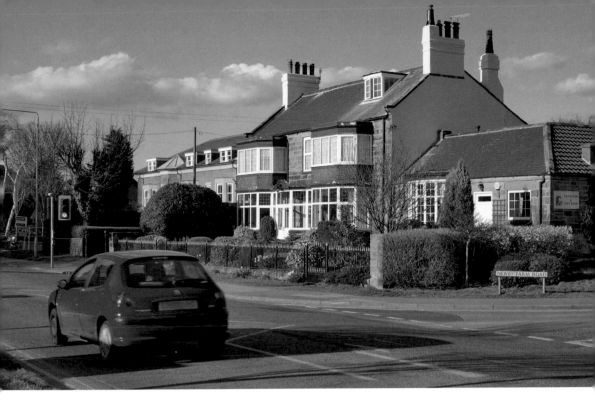

Scalby Road, Signs of Civilisation

Opposite the relatively recent bank and library this substantial stone building now has an annex housing Mad Hatties Café. Scalby Road is the main road into Scarborough from the north, and William Hutton wrote in 1803, 'Nothing marks the character of civilization more than good roads. Were the roads bad, should we venture to see our friends in Scarborough? Could the farmer bring manure to his land? There is pleasure in one, and a profit in the other.'

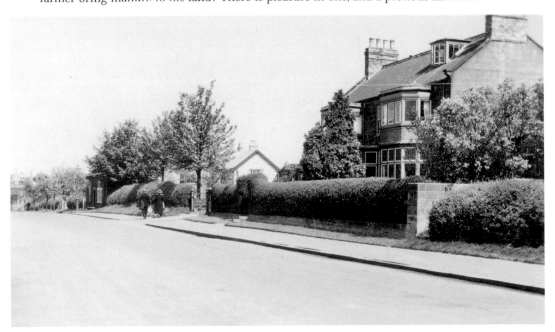

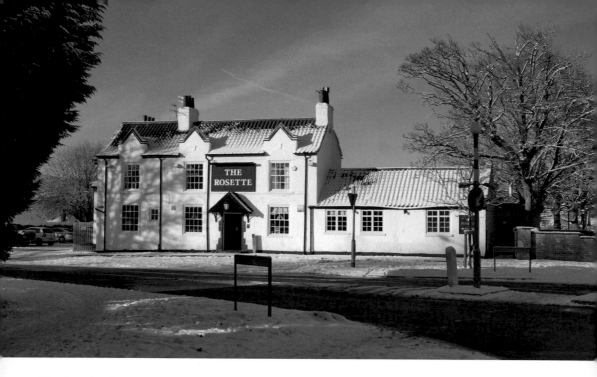

Newby: The Rosette Inn

The Rosette Inn appears on an Ordnance Survey plan of 1850 when, with Prospect Farm, they were the only buildings on the west side of Scalby Road in the village of Newby. The sign above the door of the inn indicates that Caroline Bottomley was the victualler here when the photograph was taken in about 1918. Around that time a glass of beer cost 1*d* or 1½*d*, spirits 2*d* and a bottle of whiskey 2/8*d* (14p!). The building has been extended and altered over the years as can be seen from the photographs on this and the opposite page.

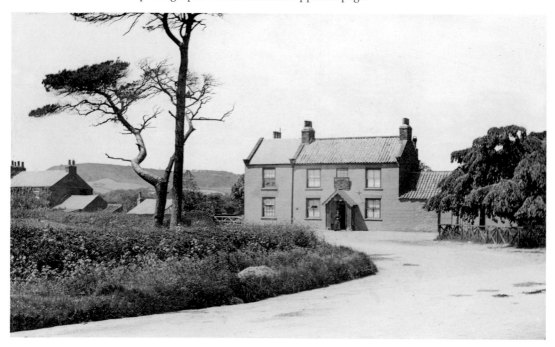

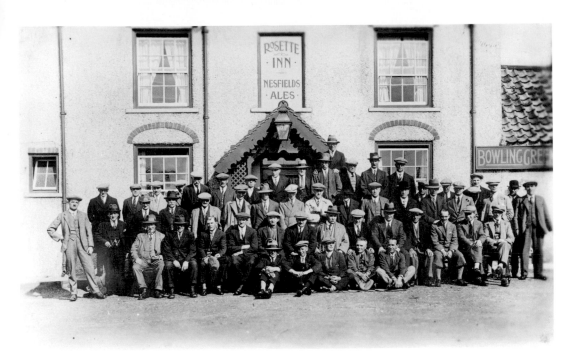

Men Only at The Rosette?

It would appear from these two photographs that only men were catered for here (see caption page 73), but this may partly be explained by the prominent 'Bowling Green' sign on the front of the building and the fact that a game of bowls was in progress round the back in the lower photograph. The bowling green is now occupied by a large extension to the inn that has provided an extensive lounge bar and eating area, and a children's play area. The origin of the name of the inn is a mystery.

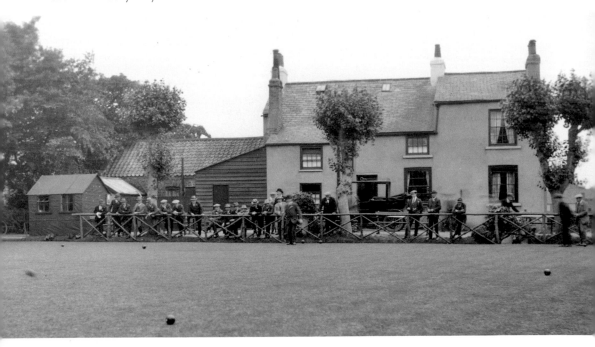

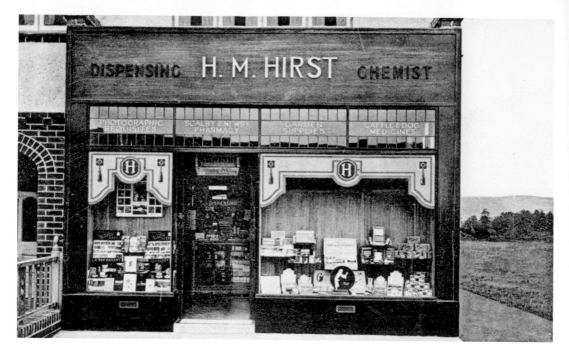

The Newby Chemist

Harold M. Hirst was the Newby chemist for many years and the author remembers going into the shop as a small boy and staring in wonder at the giant glass flagons containing a number of different-coloured and mysterious liquids. The shop was opened on 15 April 1933, and was advertised as the model chemist's shop of the North Riding. It is still a pharmacy, but Scalby Library has been built on the right and a dental surgery has moved into the adjoining house on the left.

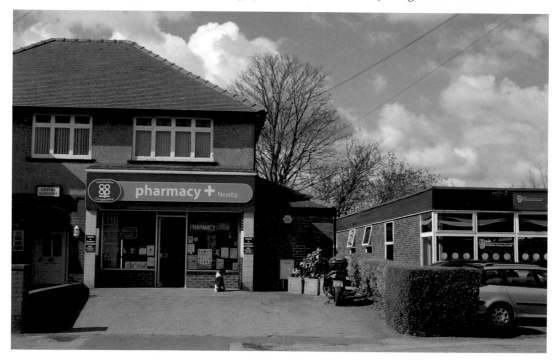

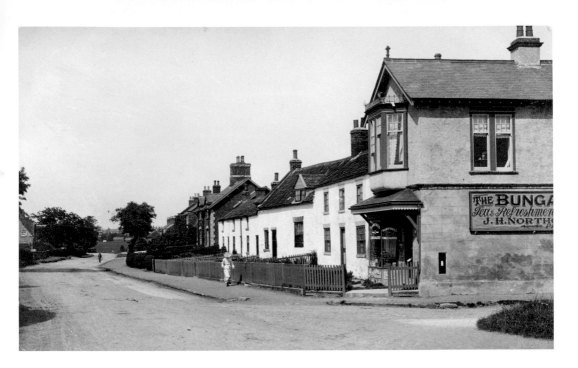

Coldyhill Lane Corner on Scalby Road

The old photograph was taken in about 1905, when J. H. Northrop's tea and refreshment rooms, 'The Bungalow', stood at the end of Coldyhill Lane. In the 1950s, it was popular with pupils from the newly opened Newby County Primary School, who bought liquorice root, thick black sticks of 'Spanish' and sherbet fountains. Most of the original whitewashed cottages were demolished to make way for a petrol station. The Bungalow, later a ladies' dress shop, has gone full circle and is now the 'Corner House Tearoom'.

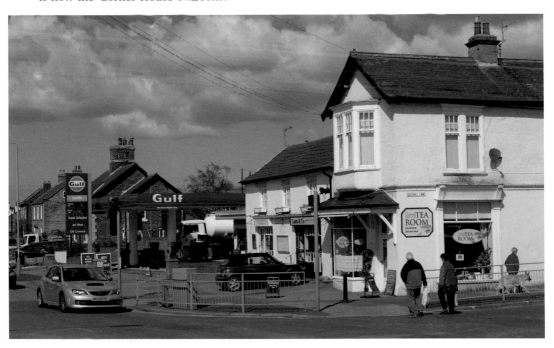

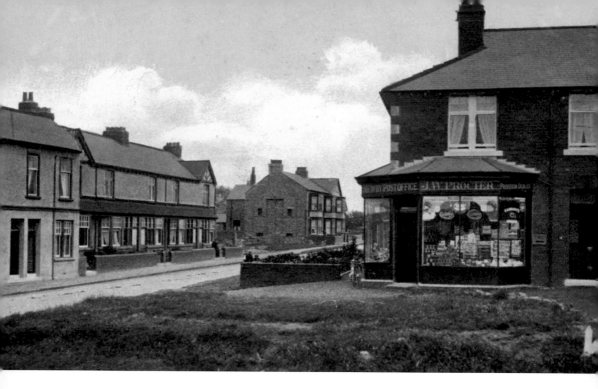

Newby Post Office: An Ever Expanding Business

Newby Post Office occupied the opposite corner of Coldyhill Lane, where J. W. Procter also ran his grocery business. By the 1950s, the shop had expanded into the adjoining house and the author remembers its dark mahogany counters and an amazing variety of provisions and utensils. It too was popular with small hungry boys as it sold brown paper bags full of broken biscuits for a halfpenny or a penny a bag and you were lucky if you got a broken custard cream! Below – adverts for local businesses in 1925.

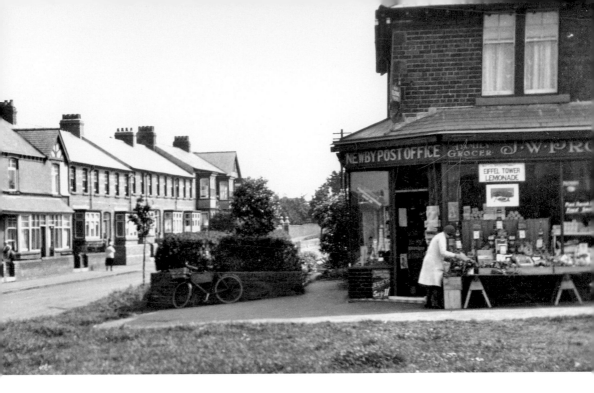

Newby Post Office: An Ever Changing Scene

As the business expanded the premises were too small and in the old photograph a multitude of provisions and goods have had to be supported on a trestle table outside. The Proudfoot Group took over the grocery business and post office from Procter's to create a new supermarket. This is just undergoing its fourth expansion by the demolition of a pair of adjacent houses on Coldyhill Lane to create an extended loading bay and increased storage facilities and sales area.

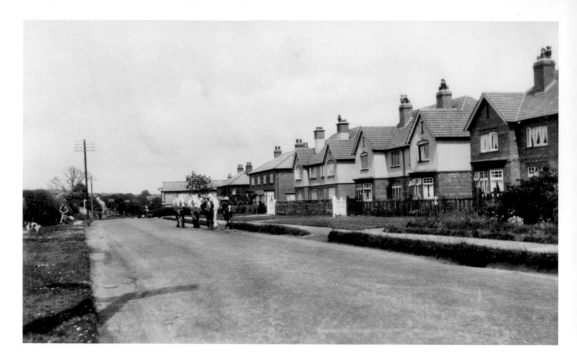

Scalby Road: A Change of Horse Power

Procter's Post Office can be seen just to the right of the horses. Next to that on the right, the pair of semi-detached houses was demolished to provide a car park for Proudfoot's supermarket. More recently, the adjacent pair of gable-fronted houses was demolished to allow for further extension to the business. A total of eight houses (including the original shop) have been demolished to serve the growing needs of an ever increasing population in Newby. Below – giant haystacks on the move!

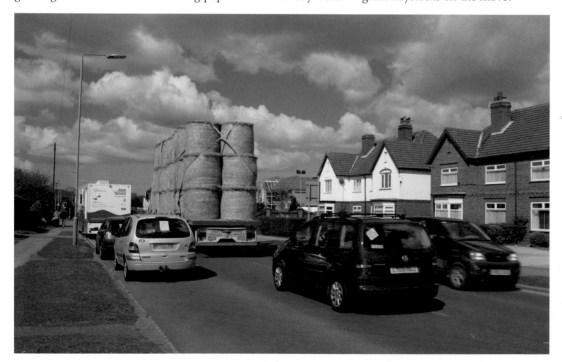

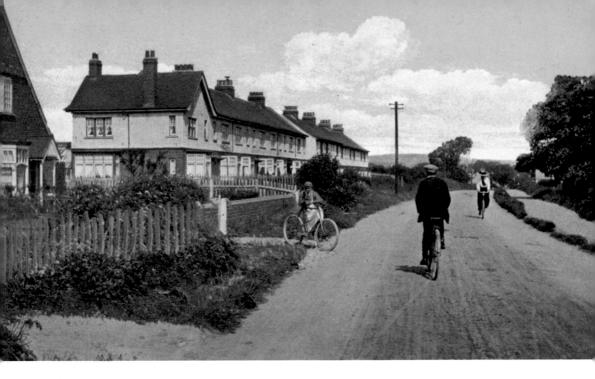

Raincliffe Terrace, Newby

Before the roads were crowded with motor cars it was a pleasure to cycle around the villages, and from this view of Raincliffe Terrace on Scalby Road, taken in about 1913, it appears that bicycles had the roads to themselves, but not for long as the later card shows an early single-decker bus heading towards Scarborough. In the distance are the white buildings of Prospect Farm, which later became a garage where small boys used to cajole the mechanics to give them ball bearings in order to play marbles.

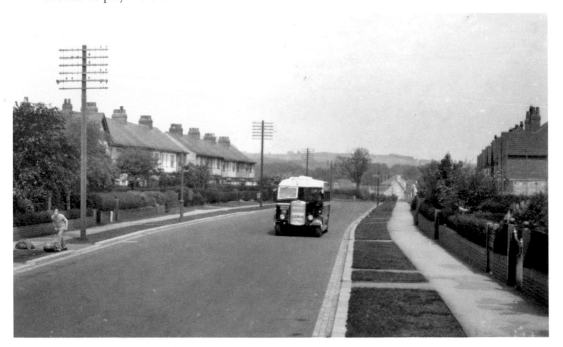

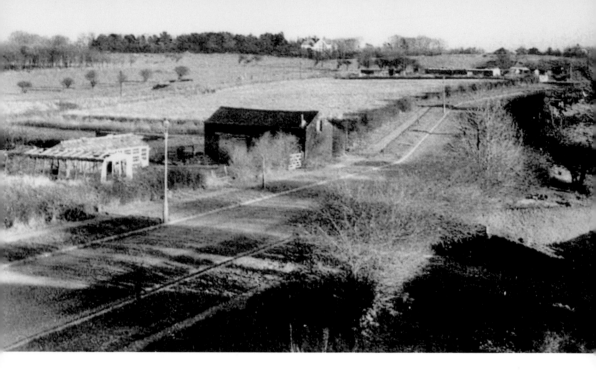

Coldyhill Lane: The Vanishing Fields

This view of the top end of Coldyhill Lane was taken in 1944, from the end of Scalby Avenue. This is how the author remembers it when Wooton's Farm, Black Barn, and allotments occupied the land on the east side of Coldyhill Lane. To the left, beyond the field, is the North Cliff Golf Course, and between the two the old railway line to Whitby. Now there are houses and bungalows on the left side all the way up to Cross Lane.

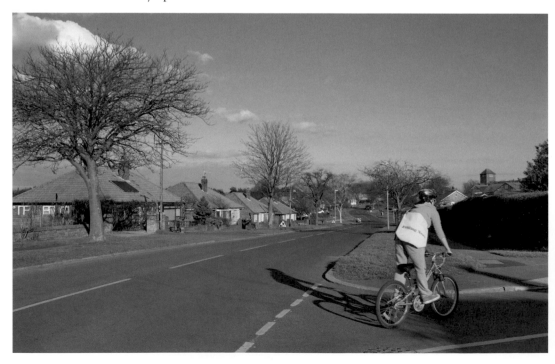

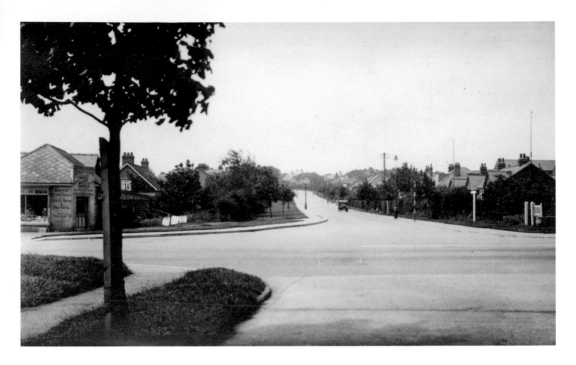

Cross Lane from North Cliff Avenue

A solitary motor car comes down Cross Lane towards the Burniston Road crossroads. On the left, the corner shop was the Burniston Road Grocery Stores run by Herbert H. Cole & Son. A large sign next to the door advertises that they were 'Agents for Lyons Cakes'. This corner site is now occupied by a new Tesco Express. North Cliff Avenue, in the foreground, leads down to the golf club that originally opened in 1909 as a six-hole course on the cliffs nearer to Scarborough (see page 87).

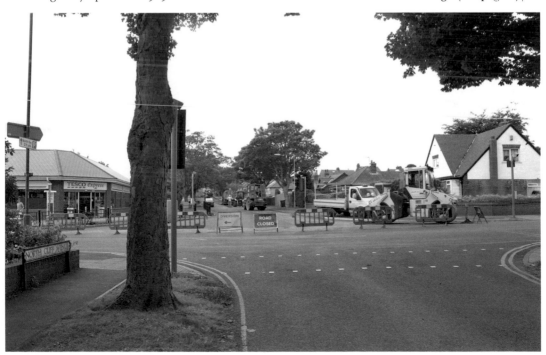

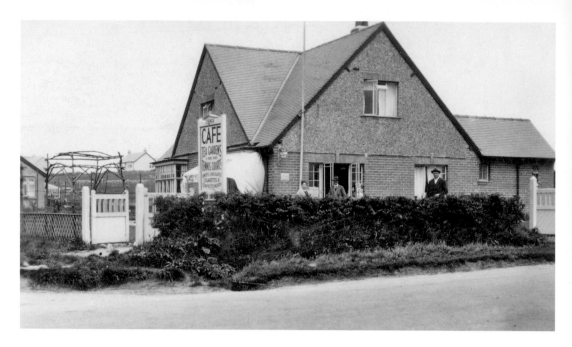

Signs of the Times

On the opposite corner to the Burniston Road Grocery Stores, at the bottom of Cross Lane, the Corner Café Tea Gardens boasted 'Public Hard Tennis Courts', as well as selling sweets, chocolates, cigarettes and confectionery. This photograph dates from about 1928, while the recent photograph, taken in 2010 when Cross Lane was being resurfaced, shows how the building, no longer a café, has been altered with the addition of a new chimney stack.

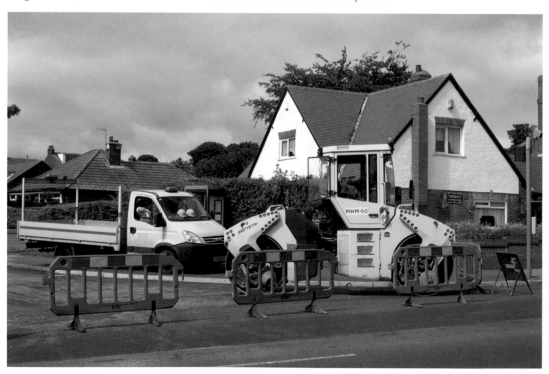

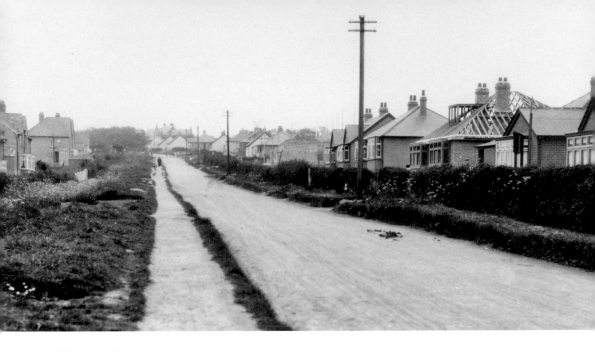

Filling the Gaps on Cross Lane

This undated photograph shows some of the last houses being built on Cross Lane. On the right, the unfinished roof of a bungalow stands out clearly and further up the road scaffolding poles for other houses can be seen. The road was completely resurfaced just before the bad winter of 2010/11 created enormous potholes in many roads. W. Hutton, in 1804, had some advice on roads: 'Much trouble and expence (sic) are saved in forming a road at first; or you may everlastingly botch it, and it will still be a bad road.'

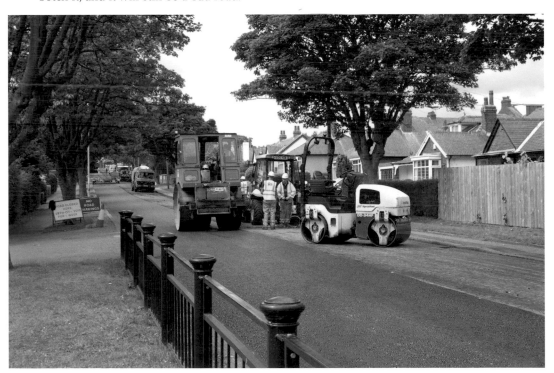

Green Lane, West End

A relatively recent development and expansion of Newby came with the building of Green Lane and the avenues and roads that lead off from it. Only one house was recorded on Green Lane in the *Directory* of 1932, and that was number one at the Scalby Road end, opposite the corner shop (see next page). Two years later a *Directory* records about fifty houses as being occupied along Green Lane. West Park Avenue leads off to the right and behind the camera Green Lane joins Scalby Road.

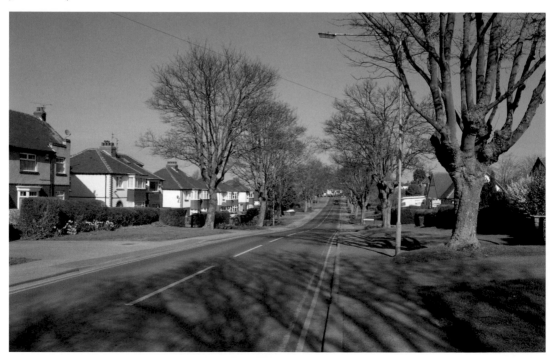

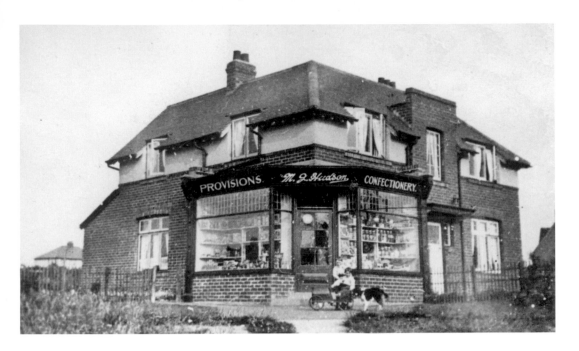

Green Lane: The Corner Shop

Like most of the other corner shops illustrated in this book, this one has also been converted for purely residential use. The building stands on the corner of Green Lane and Scalby Road, and in the old photograph it was a shop selling provisions and confectionery run by M. J. Hudson. The author remembers it in the 1950s as a general store run by the Bool family. In the directories J. B. Bool was grocer here in 1952, and H. & R. Atkinson ran the grocery in 1976.

Red Scar Lane

Red Scar Lane comes over from Throxenby Mere and down to Hackness Road in Newby. The field on the left was very popular for tobogganing in the bad winters of the 1950s. More houses have been built on the right hand side of the lane since the old photograph was taken in about 1930, and a new road on the right, Red Scar Drive, connects through to Moor Lane. The houses in the distance at the bottom of the field are on Hackness Road (see page 28).

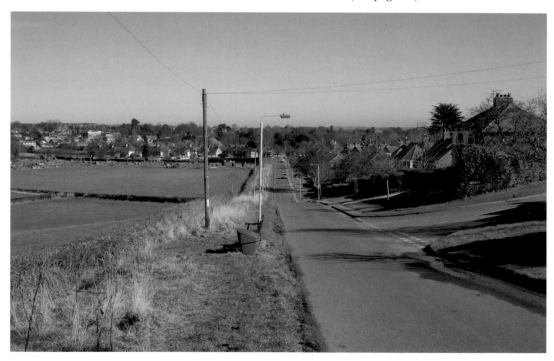

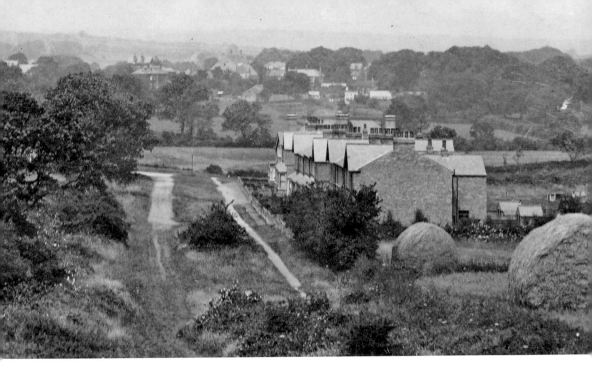

Moor Lane: A Roman Road

The Scalby end of Moor Lane has seen many changes since the old photograph was taken and it is reputed to have a history dating back to Roman times. The right-hand 'track' appears to be paved and has the appearance of a stone trod – long distance footpaths dating back two or three centuries. On the right, the shapely haystacks stand where there are now houses and bungalows. More remarkably, there is not a single building on the left side of the road, which peters out completely in the foreground.

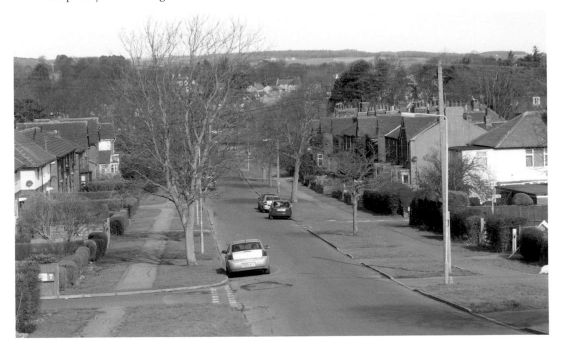

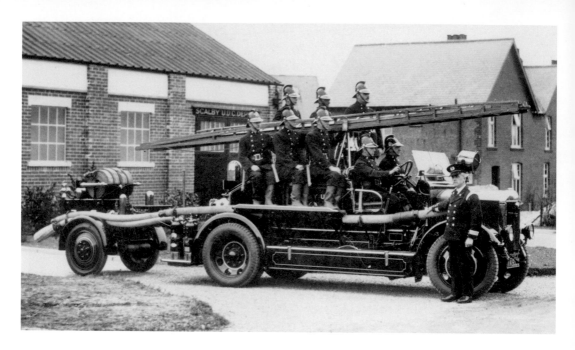

Scalby Fire Station on Moor Lane

Prior to 1938 there were about 1,500 small fire brigades run by local councils in Britain. Scalby Fire Brigade was formed in 1934, and the opening ceremony was performed by Sir William Wordsworth. The Volunteer Fire Brigade, ready for action, pose with their engine and trailer outside the fire station, which was part of the Scalby Urban District Council Depot near the bottom of Moor Lane. The depot was demolished and replaced by the houses seen in the picture below.

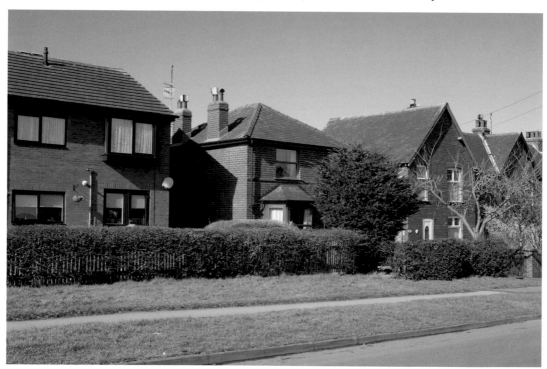

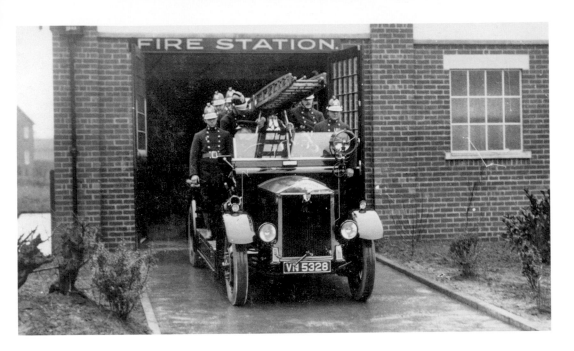

Scalby Volunteer Fire Brigade: Under Pressure

The fire engine, a fine vehicle, sported a large brass bell and an extending ladder. The equipment, particularly the pumps and hoses, had to be tested periodically and the lower photograph shows the crew, in an unknown location beside a stream, trying out their equipment (see also page 85). The formation of the National Fire Service in about 1938 led to uniformity in the basic equipment used by the fire brigades in wartime Britain, and at the end of the war the service was taken over by local county councils.

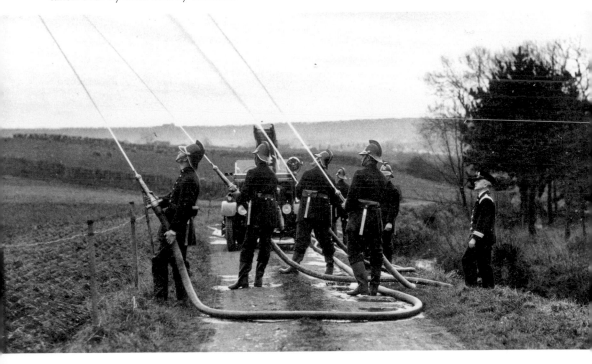

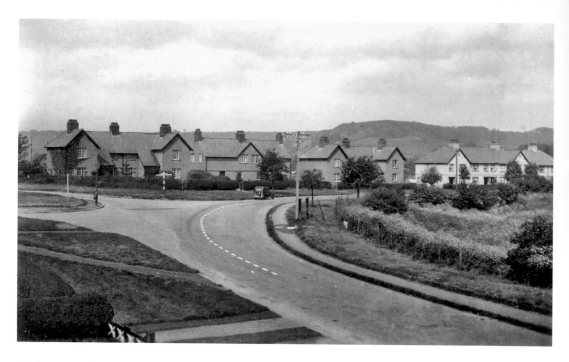

Hackness Road: Four Lane Ends

On the left, the first road is Moor Lane (page 25) and the second is Red Scar Lane (page 24) leading to Throxenby Mere and Forge Valley. Hackness Road, in the foreground, curves to the right on its way to Scalby, Hay Brow and Hackness. The 1851 Census recorded only seven households in Newby. The population in 1882 was 40 and by 1901 it was still only 96, but by 1951 it had exploded and reached over 4,000!

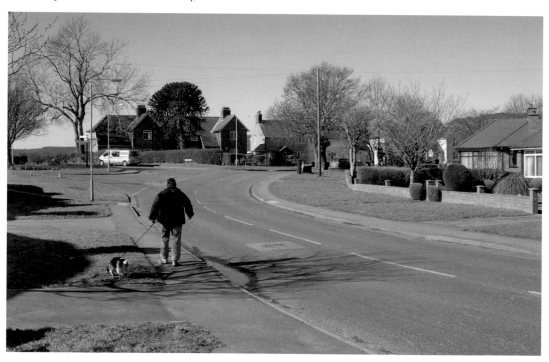

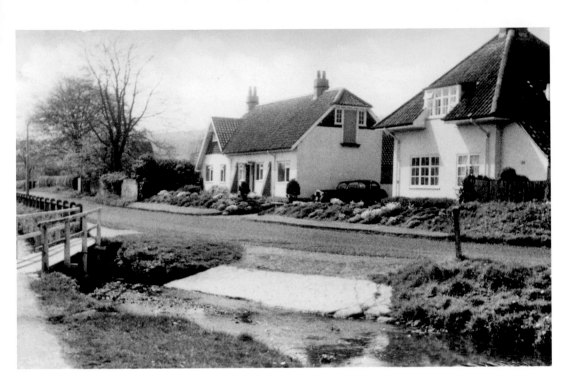

Hackness Road: Low Hall Cottages

Low Hall cottages, erected in 1906, are thought to have been built on the site of the original Low Hall that was replaced, further up the road, by the new Low Hall, built by J. W. Rowntree in 1904 (see pages 34–35). Low Hall cottages were derelict for a few years, but have recently been restored to their former glory with the addition of some attractive dormer windows. The ford in the foreground was part of the original road into Scalby, but has since been blocked for road traffic, although the footbridge still survives.

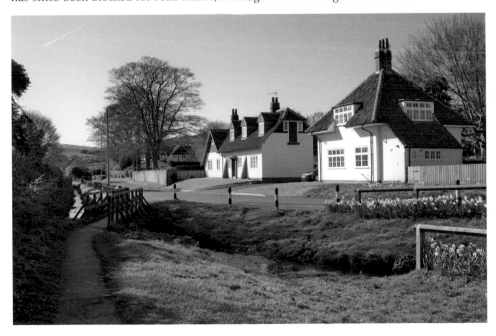

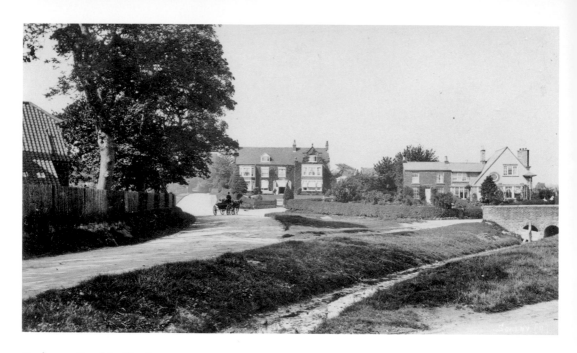

Hackness Road to Hay Lane

On the left the Hackness road continues up the hill as Hay Lane leading to Hay Brow, Suffield and Hackness. This road was built to the order of Sir Richard Vanden Bempde Johnstone Bart, the owner of Hackness Hall, at a cost of around £600 in about 1810. Church Beck passes under the double-arch bridge that carries the road up to Scalby village. The Ordnance Survey plan of 1852 shows a ford and footbridge here before the road bridge was built.

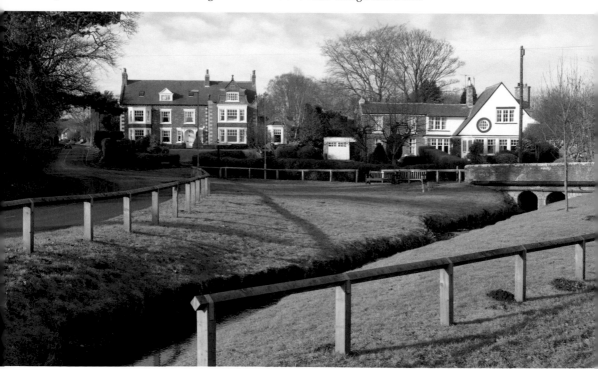

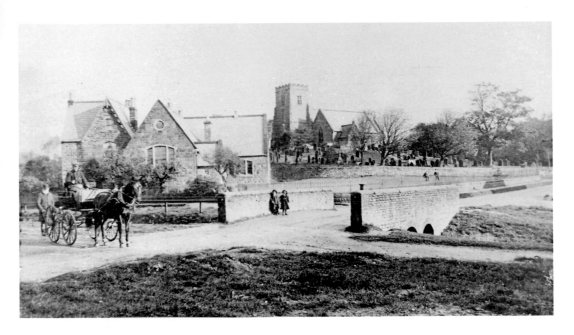

Scalby School and the Church on the Hill

The foundation stone for a schoolroom was laid here on 1 August 1828 by the Revd C. A. Thurlow, Vicar of Scalby from 1827–40. The school was rebuilt in 1861 and enlarged with the addition of a new schoolroom, which could be divided by curtains, and a head teacher's house. Mr John Tickle was schoolmaster here from 1883 to 1922. The average attendance in 1890 was 120. The school closed in 1950 and is now known as the Community Rooms, providing accommodation for groups and organisations.

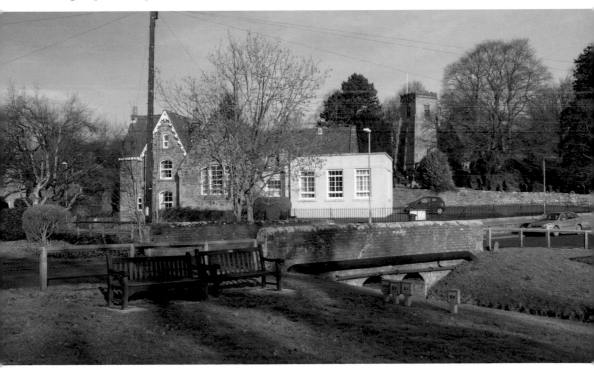

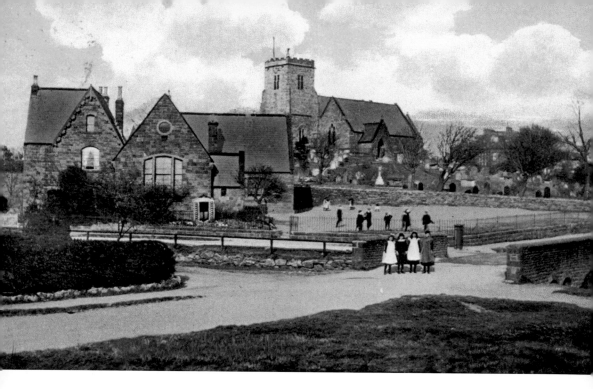

School's Out!

Both of these photographs were taken a hundred years ago in 1911. The coloured one is from an old postcard that is postmarked 2 August and bears the message: 'When I woke up this morning I heard something squeaking which sounded as though it was in the bathroom. I went to look and I found it was a kitten!' The second photograph was taken in the school yard on the occasion of the hoisting of the coronation flag on 6 May – celebrating the crowning of King George V.

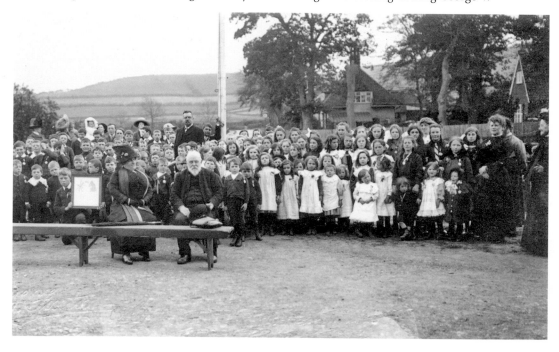

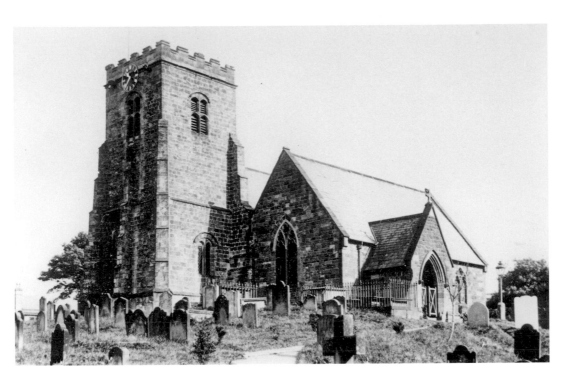

Scalby Church: A Sylvan Encroachment

St Laurence church records go back to the thirteenth century, but parts of the church are older than this as it was presented to the Prior of Bridlington in about the year 1150. It now comes under the Dean and Chapter of Norwich. Records show that the tower was rebuilt in 1683, but the two original bells are dated 1674, and a third bell was added in 1919. Three more bells were added in 1961, and they provide a tuneful sound calling to the community right across the parish.

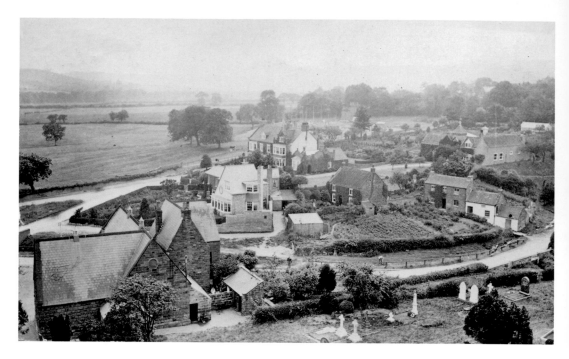

Church Becks: The Loftier View, 1904 and 2011

Looking west from the top of the church tower, the area known as Church Becks spreads out beyond the churchyard. On the left are the village school and adjoining head teacher's house. Behind them and running off to the right is Carr Lane and above the school roof Hay Lane starts its ascent to Hay Brow. Above the large house in the centre, the scaffolding for the building of the new Low Hall can be seen faintly outlined against the trees. Comparison of the two photographs reveals a number of changes.

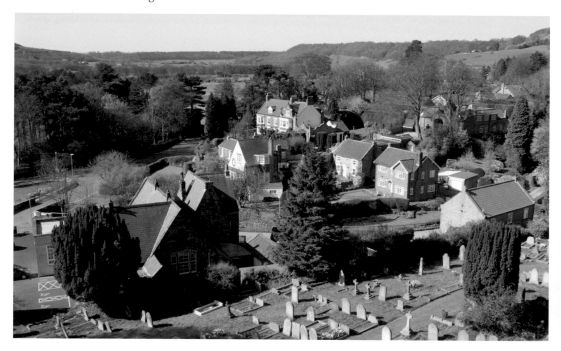

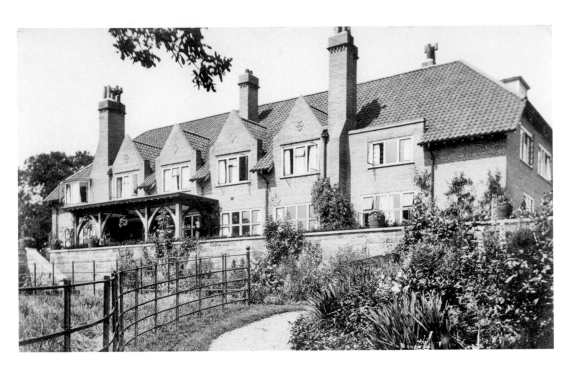

Low Hall: From Major to Miner

Low Hall, on Hay Lane, was built for John Wilhelm Rowntree, a prominent member of the Society of Friends (Quakers). The upper floor of Low Hall was designed to accommodate guests attending adult schools in the area, including Friedensthal (pages 36–37). The Rowntree family moved to Langdale End in 1924, and Low Hall was purchased in 1926 by the South Yorkshire Miners Welfare Committee for use as a Convalescent Home. The current owners are the National Union of Miners (Yorkshire Area), who purchased it in 1977. Note the addition of dormer windows.

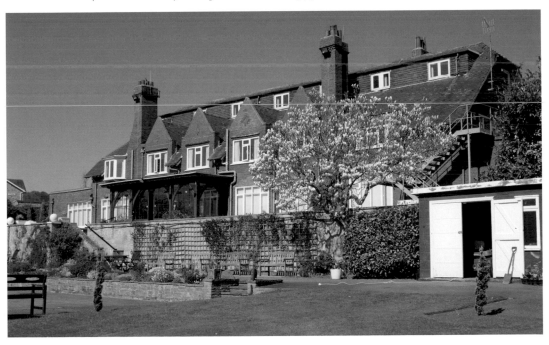

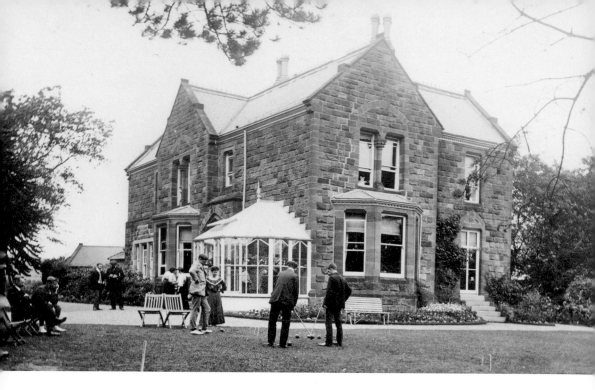

Friedensthal: A Peaceful Retreat

Friedensthal opened as an adult guest house in 1904 and was rented from J. W. Rowntree of Low Hall until it closed in about 1920. Later it became Uplands School for private pupils, and was eventually demolished to make way for the residential development of Wordsworth Close off Hay Lane. Adult schools were popular for many years – outdoor activities were provided including bowls, tennis and croquet, seen above; and below the dining room set for the guests, adorned with vases of sweet peas.

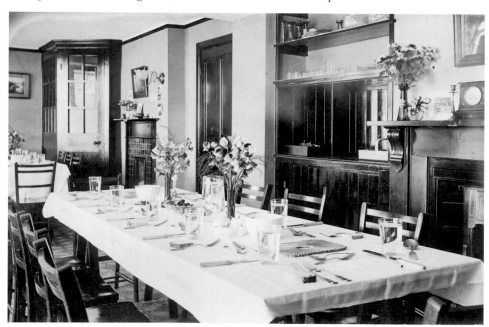

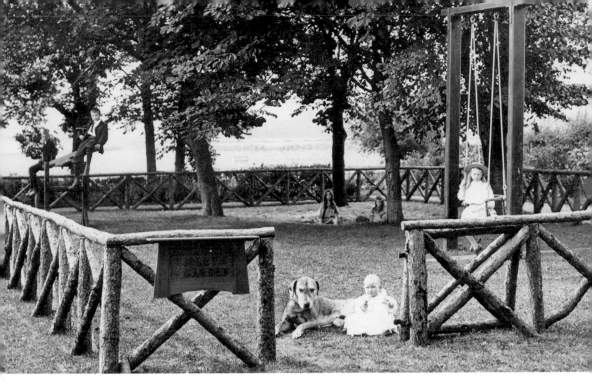

Friedensthal: Happy Memories and Fond Farewells

Children were catered for as well as adults, and swings, a climbing frame and a sandpit were provided in 'Violet's Garden'. No doubt guests were sad when their holiday came to an end, but so were the staff and the dog. In the lower photograph tears are being shed – those of the dog pouring down the steps! When Friedensthal finally closed, Cober Hill at Cloughton took over as the local adult school guest house (see the companion volume in this series *Burniston to Ravenscar Through Time*).

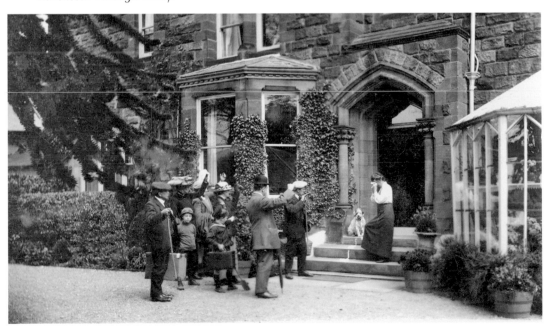

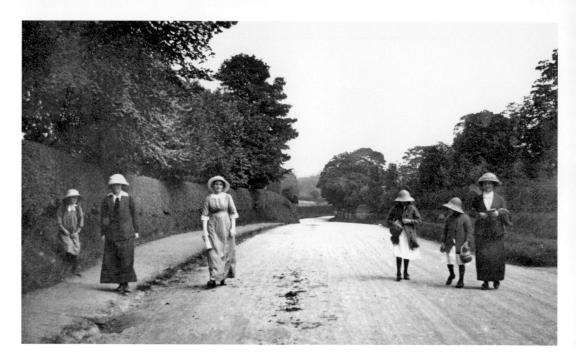

Two for the Ladies ...

This group of young ladies was photographed in 1915 just above Friedensthal on the Hay Brow road, looking down towards Church Becks. In the lower photograph, one of the most colourful stalls, at the June 2010 Scalby Fair, had a World Cup football theme, and was manned by local ladies in aid of the Elder Tree Luncheon Club. The ladies were delighted to win the well-deserved first prize in the best decorated stall competition.

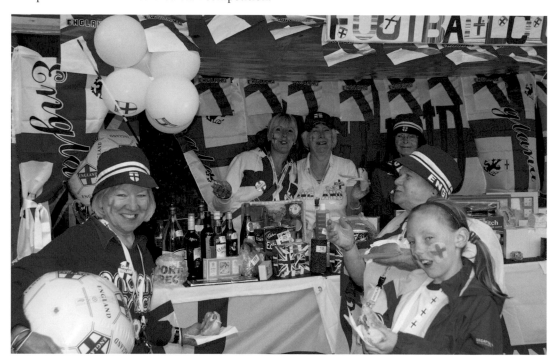

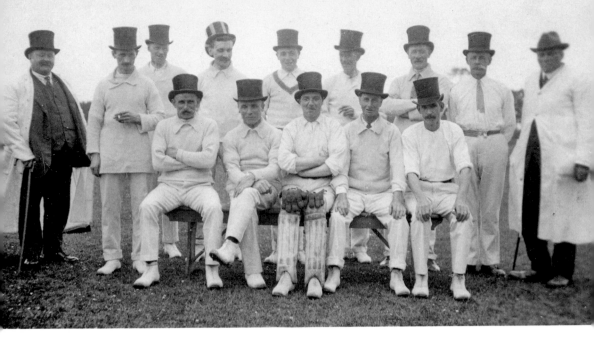

... and Two for the Gentlemen

Scalby Cricket Team, in top hats, poses for a photograph at Field Close Farm (pages 68–69) in July 1910. Scalby Cricket Club was formed by 1865 and now has three senior and three junior teams playing in local leagues. They have two grounds, the main one being up Carr Lane (page 34), the other on Scalby Road towards Burniston. In the lower photograph, Scalby Men's Choir, a very smart and happy-looking group, pose for their photographs outside an unidentified building.

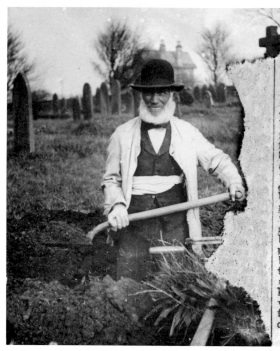

SCALBY JACK=OF=ALL= TRADES.

A reader forwards an interesting adver-
tisement relating to a late Scalby worthy,
whose many sidedness is indicated in it. It
has previously been published. but it will
repay further perusal. It reads as
follows:—" Enos Thompson, Scalby, near
Scarborough, sexton, joiner, builder
and undertaker, painter and grainer, white-
washer and paperhanger, plumber and
glazier, whitesmith, locksmith, gasfitter and
bellhanger, carver, gilder, and picture frame
maker, watch and clock repairer, wheel-
wright, etc., begs to inform the clergy,
gentry, and inhabitants of Scalby and neigh-
bourhood that, having had considerable ex-
perience in the aibove branches of business,
he will be glad to receive any orders en-
trusted to his care, and can with confidence
assure them that such orders will receive
his immediate and best attention, combined
with punctuality, practical experience, and
first class workmanship with moderate
charges."

Rare Breed: A Multi-Tasking Man!

Seen in his role as Sexton, Enos Bravender Thompson was a man of many talents, as recorded
in a local newspaper. A very busy man, he must have found his work as gravedigger, though
strenuous, quite peaceful as the graveyard is beautifully situated around the church and
overlooking Scalby Becks on the south side. His grave is west of the church tower – what better
place to be laid to rest after a life of toil in the service of the community? His headstone (on the
right) records that he died in June 1912, aged seventy-eight.

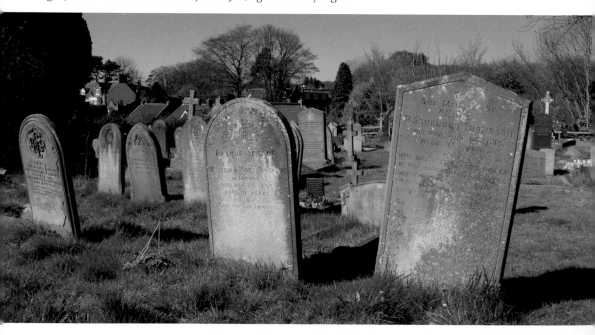

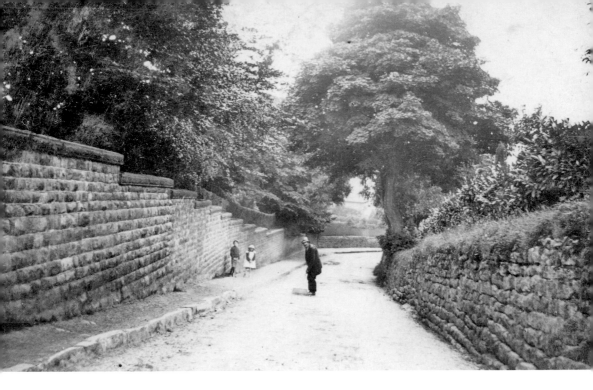

Church Hill: A Cleaner Road

Church Hill, with the graveyard above the wall on the right, has changed very little over the last century and is part of a delightful walk from High Street down to Church Becks. The old photograph was sent in April 1915 as a postcard to Cpl Gordon Tickle, who was serving with the 10th Canadian Mounted Rifles. John Tickle was headmaster at the Church School, just down the road, and the message on the card ends with, 'Do you recognise old Harper Cowton sweeping Church Lane?'

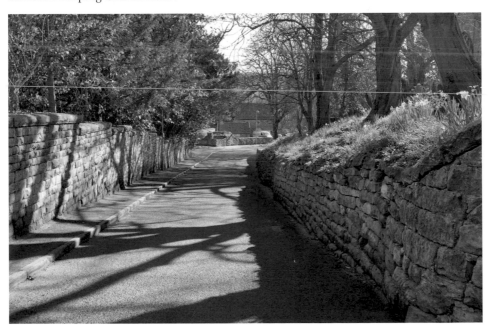

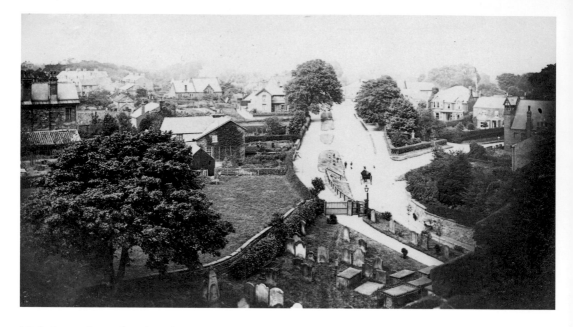

High Street from the Church Tower

The top photograph was taken in 1905, and shows the High Street looking towards the centre of the village. Low Street veers off to the right and the first building, seen on the extreme right, was the Primitive Methodist Chapel (see opposite page). The present-day view from the tower is largely obscured by trees. The church is dedicated to St Laurence, who is reputed to have been burnt to death on a grid-iron – this is shown on one of the panels of the east window (below left), which tells the story of St Laurence. A central panel in the top of the window (below, right), which shows the Holy Spirit in the form of a dove, bears seven tear-shaped tongues of fire that have been interpreted in a number of ways, but may represent the meteors that fall around the time of St Laurence day, 10 August, as they are known as the 'tears of St Laurence'.

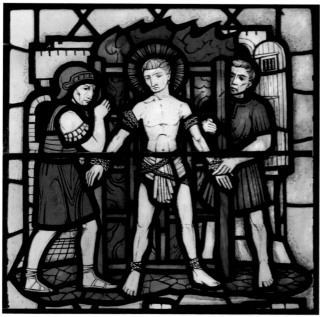

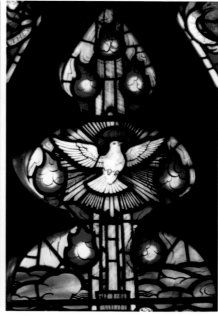

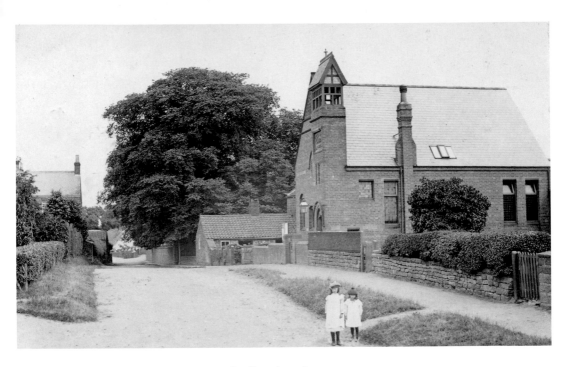

Low Street and the Primitive Methodist Chapel

This substantial building was erected in 1895, and the photograph was taken ten years later when John Tickle (page 41) was recorded as Clerk to the Primitive Methodist Chapel in 1905. Some of the character of Low Street was taken away when the chapel was demolished to make way for a modern bungalow.

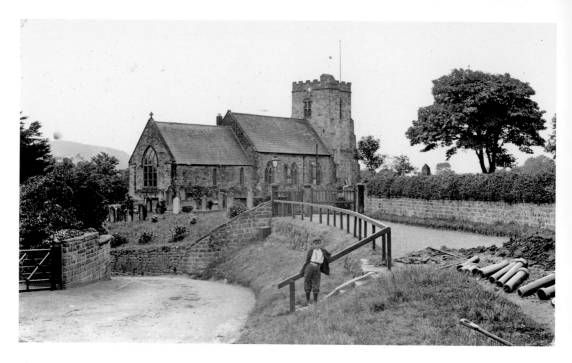

The Approach to St Laurence Church

The old photograph was taken in about 1912, and was printed as a postcard that bears the following message: 'I like this part very much it is so very pretty and it is a very nice Church and Vicar kind.' The vicar at the time was William Cautley Robinson, who was incumbent here from 1876 to 1915. In snow and sunshine the approach to St Laurence church is still 'very pretty', although the church itself is now largely obscured, from this direction, by trees.

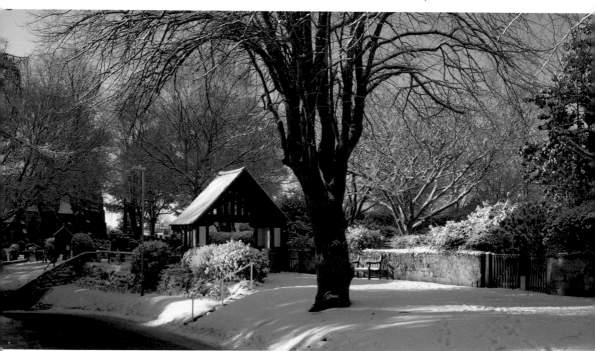

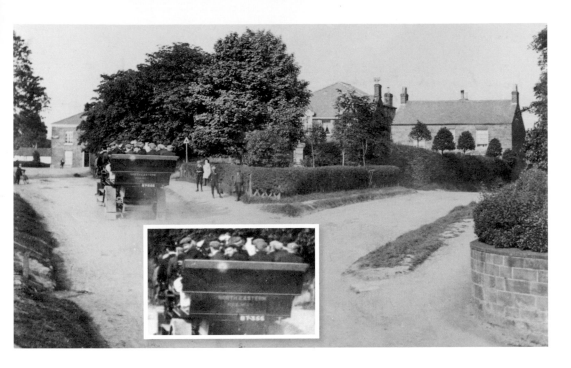

Scalby High Street: On the Tourist Route

A North Eastern Railway charabanc carries a full complement of passengers up High Street, past Low Street on the right, towards the Nags Head Inn. The NER ran tours from the station forecourt at Scarborough from 1906 to 1913. Six out of the eleven tours to local beauty spots included Scalby in their itineraries. Tour number one included North Bay, Barracks, Scalby Mills, Burniston and Scalby, a distance of seven miles at a cost of one shilling (5p)! (See *Scarborough & Whitby Railway Through Time.*)

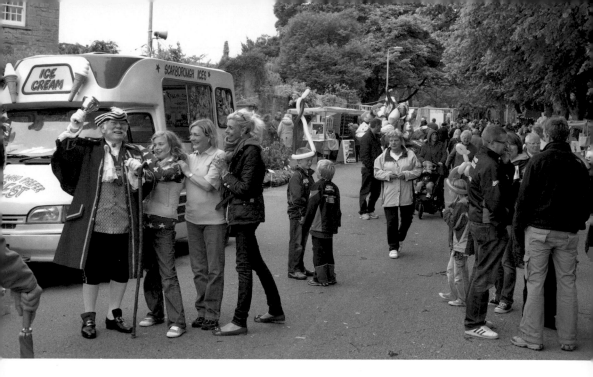

The Bell(es) of Scalby Fair

High Street looking south-west towards St Laurence Church in 2010 (above) and in about 1925 (below). Scalby Fair originated in the sixteenth century when Midsummer Day was celebrated, but this ceased in the 1860s. It was revived in 1977 when a street party was held to celebrate Queen Elizabeth's Silver Jubilee and a Scalby Fair & Flower Festival Committee formed. Scalby Fair has been held ever since and a popular visitor, who adds a flavour of tradition, is the Town Crier, Alan Booth MBE.

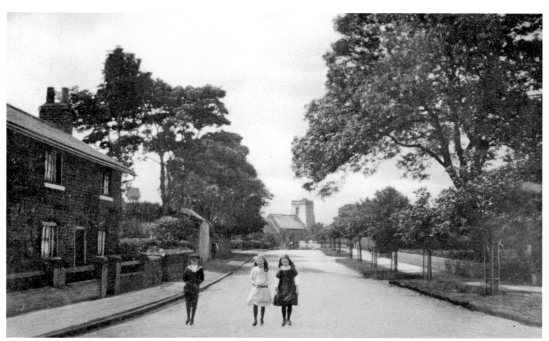

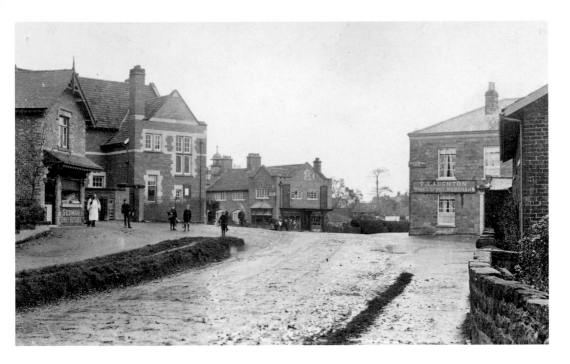

Meat at the Crossroads

This view of High Street in 1905 shows Sedman's Family Butcher, on the left, and T. Laughton's Nags Head Inn, on the right. John Sedman was recorded as a butcher in Scalby in 1890, but the shop was later closed and the room incorporated into the house. The T. Laughton of the Nags Head Inn was the uncle of Tom Laughton the hotel keeper and public benefactor who died in Scalby in 1984, shortly after donating a third important collection of paintings to Scarborough Art Gallery.

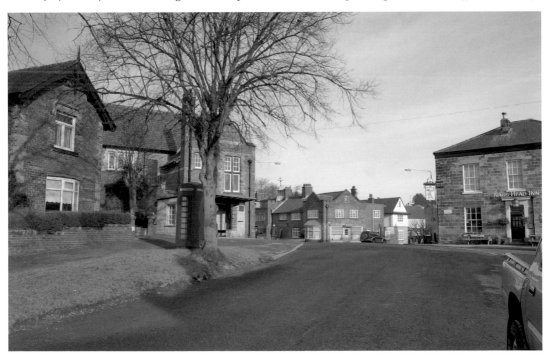

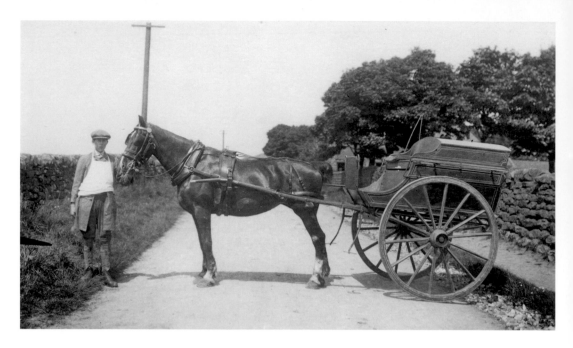

Transports of Delight

In 1890, the Cockerill brothers, George Henry and Dickenson, were recorded as butchers at Scalby, although their home was at Burniston. The photograph is thought to show Gilbert Cockerill with their delivery 'van'. In 1905, George H. was recorded as a farmer at Cumboots (north of Scalby village), and D. Cockerill, butcher, was living at Curraghmore Terrace (see page 53). Below, two well-respected gentlemen farmers of Scalby, Mr Leng and Mr Ashton, both aged seventy-five, were photographed on a jaunt in a hay cart in about 1930.

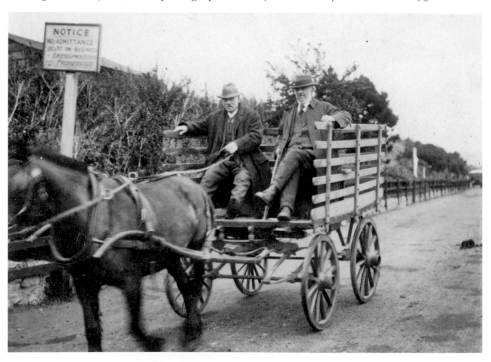

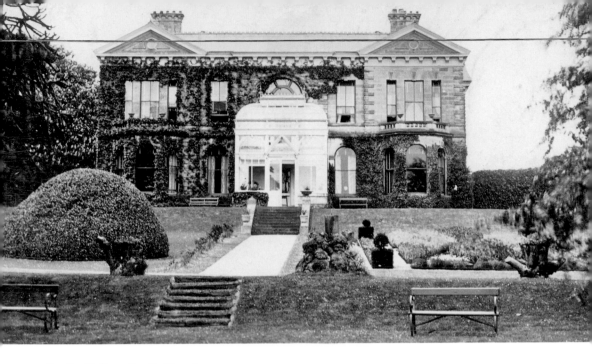

Scalby Hall on South Street

This building was marked on the 1852 OS plan as Scalby Villa, and it is an imposing structure with its stone frontage and extensive gardens that once had a carriage drive leading down to the gatehouse next to Newby Bridge (see page 5). It has more recently been converted into flats and has lost its extensive gardens and carriage drive; this land is now occupied by the new development of Hall Park Close, Flock Leys and Scalby Beck Road.

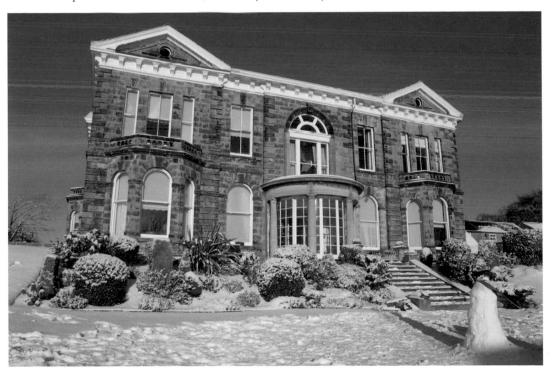

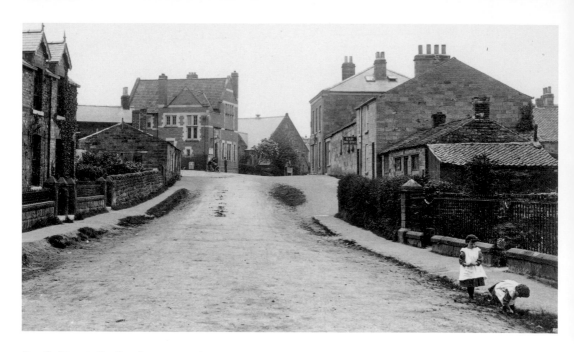

South Street, Scalby, in 1904 and 2010

The Nags Head Inn is at the far end on the right, and on the other side of the crossroads is the Scalby Temperance Hall (see page 57). At the end of the street, on the left, there was the smithy of James Boddy, but this building has been converted into garages. Scalby's third public house, the Swan Inn, was located hereabouts and is listed in Gillbanks' *Directory* of 1855. A sign at the far end of the first tall building on the right indicates the position of 'Scalby Post Office'.

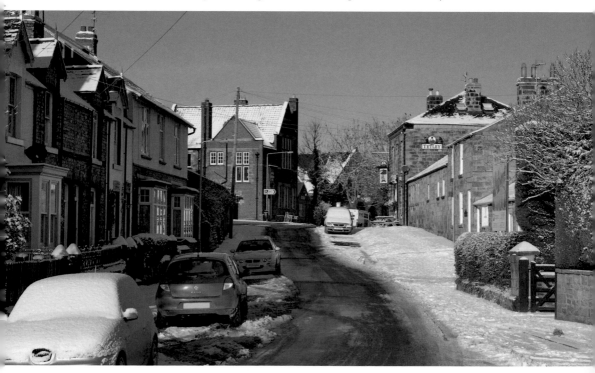

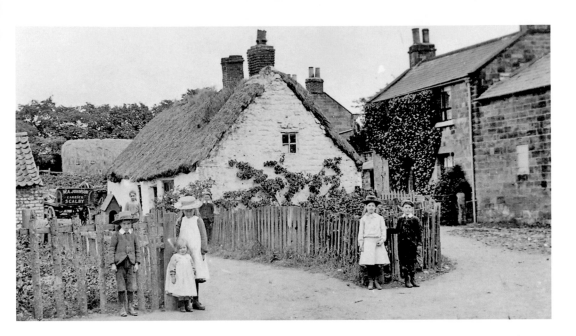

South Street: The Last Thatched Cottage

Scalby's last thatched cottage, a cruck-framed building, was still inhabited when the old photograph was taken in about 1905; the thatch was removed in 1907. The cart, next to the dog kennel in the background, bears the words – 'W. A. Johnson, Carrier, Scalby'. In the 1980s, the building was in use as a garage, as a large part of the end wall had been taken out to allow vehicular access. In 1990, it was carefully restored to domestic use by Bill Atkinson, who is sat outside 'Peartree Cottage' in March 2011.

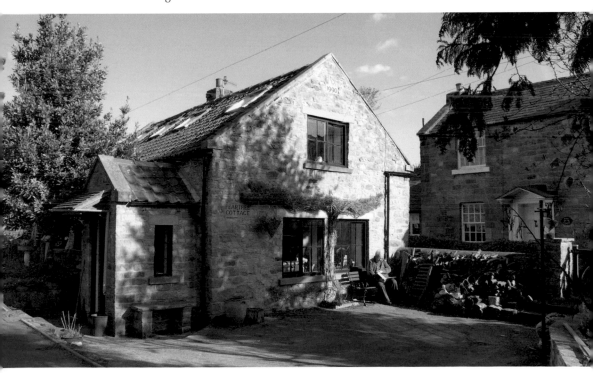

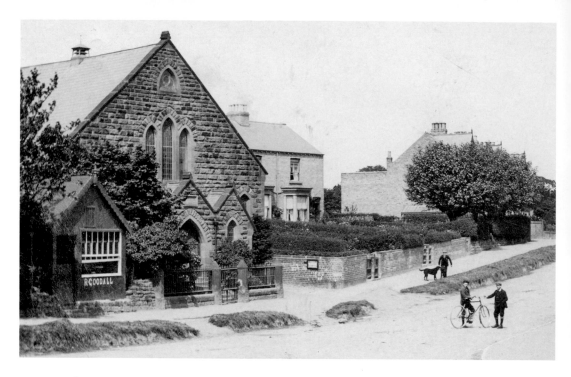

North Street Methodist Church, 1909 and 2011

This is a detail taken from a photograph showing the Wesleyan Methodist Church on North Street. On the left, the small hut of R. Goodall was a barber shop and the author remembers, as a small boy, having his hair cut rather too closely for comfort in this establishment. In the *Directory* of 1932, an R. Goodall lived on Mount Pleasant, which is the little road running along the far side of the chapel. The wooden hut has disappeared to be replaced by the brick building next to Scalby Methodist Hall (page 57).

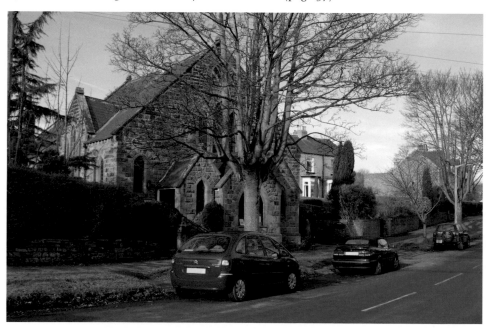

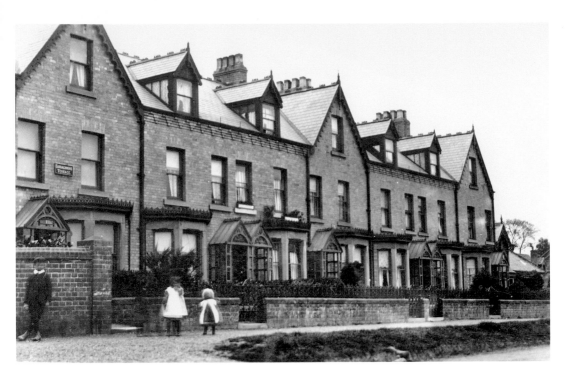

North Street: Curraghmore Terrace in 1905 and 2011

This attractive row of Victorian terraced houses still retains many of its original features, the notable exception being the loss of the ornate cast-iron 'lacework' round the tops of the bay windows. In 1905, the year that the old photograph was taken, the following people were recorded as living in the seven houses of Curraghmore Terrace – 1 Mrs Corner; 2 Tom M. Tissiman, engineer; 3 Mrs Leather; 4 not recorded; 5 Thomas Lidell, coachman; 6 D. Cockerill, butcher; 7 William Cross.

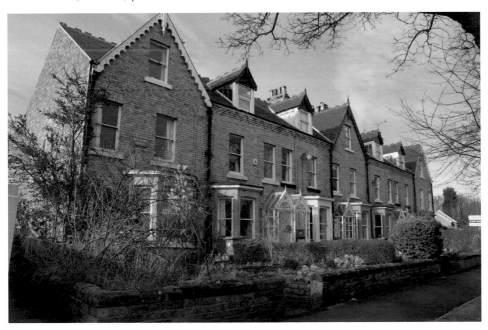

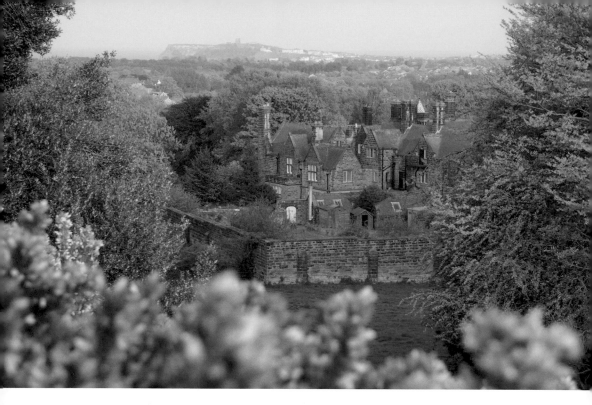

Scalby from Wrea Head

In the foreground Wrea Head, north of Scalby village, was built in 1881 for John Edward Ellis, a Quaker and a Liberal MP for Nottingham. He was a great benefactor, giving the Temperance Hall to the village (page 57) and the church clock (page 33), and his grave is in St Laurence churchyard. Beyond Wrea Head the rolling countryside spreads out towards Scarborough Castle headland and the North Sea. Below, Wrea Head in 1907, which later became a college and is now a country hotel.

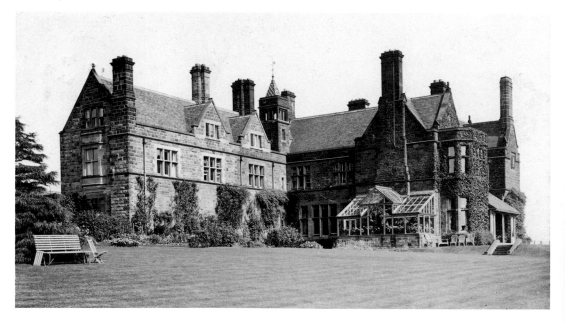

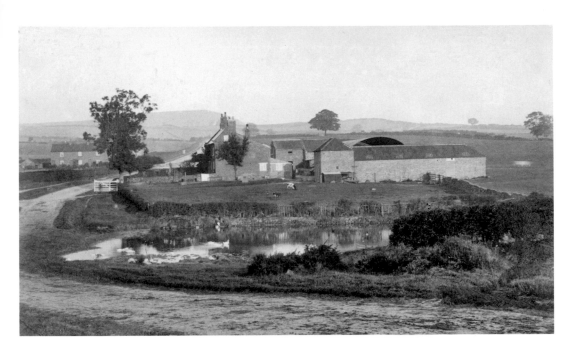

Scalby: Foulsyke Farm

Foulsyke Farm and pond is at the far end of North Street on Barmoor Lane. The farm now provides bed and breakfast in a pleasant rural location. The number of farmers in the parish remained fairly stable, at around twenty, between 1823 and 1934. Other trades and occupations recorded in 1823 include: three corn millers, two shoemakers, two wheelwrights, two victuallers (at the Ship Inn and the Oak Tree), a schoolmaster and a lapidiary. Foulsyke Pond has been cleaned up and landscaped, and is now popular with families, and the ducks!

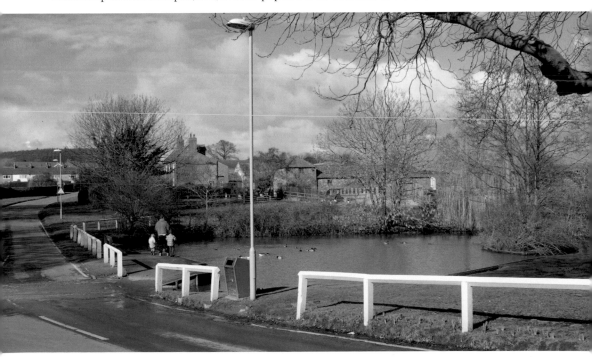

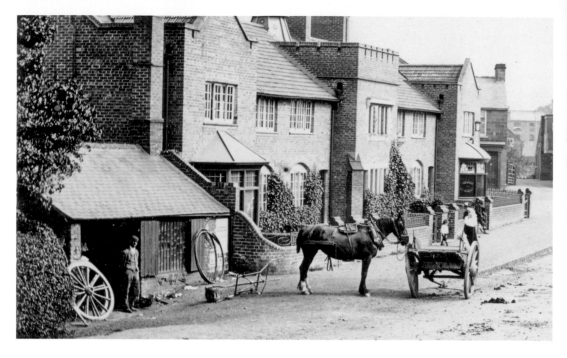

The Blacksmith's, Yew Court Terrace

This detail, from a photographic postcard of about 1905, shows the smithy of J. G. Boddy on North Street, next to the end of Yew Court Terrace. This was one of at least four smithies in Scalby (two were on South Street), but it was converted into a holiday cottage a few years ago. Directories of Scalby record the number of blacksmiths living in the village – three in 1823, two and a cartwright in 1840, three in 1890, four and two wheelwrights in 1905 – a sign of increasing road traffic even in the days of the horse and cart!

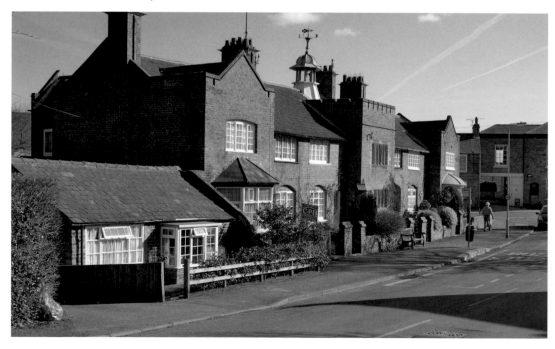

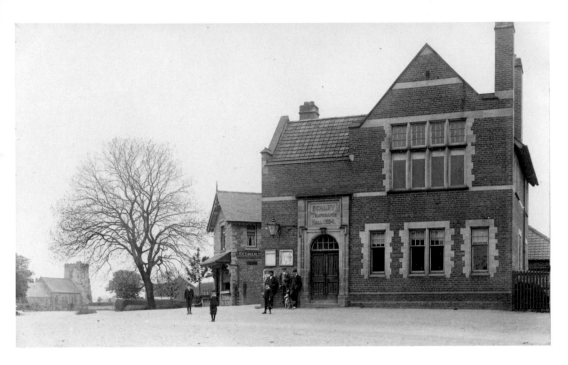

Scalby Temperance Hall

Scalby Temperance Hall bears the year 1884 carved into the ornate stonework above the entrance and was the gift of John Ellis MP (see page 54). The stone is now obscured by the sign for 'Scalby Methodist Hall'. On the left, Sedman's Butchers shop stands on the site of the old village pound and stocks. More recent additions to the scene include a bus shelter and a brick-built Unisex Salon, which replaced the old wooden hut of the hairdresser (see page 52).

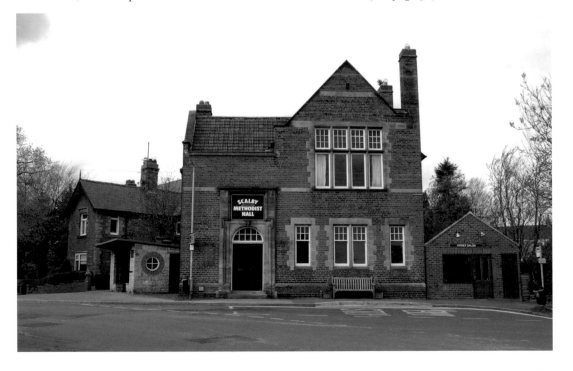

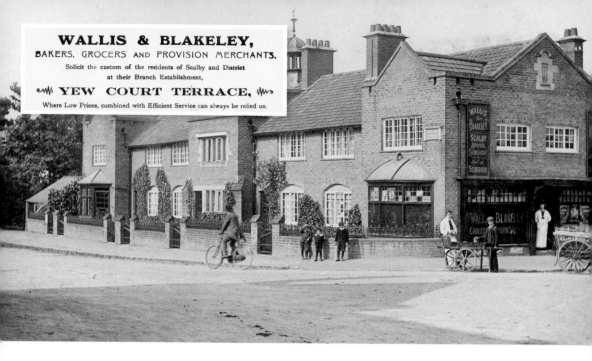

Yew Court Terrace: Wallis & Blakeley

Wallis & Blakeley were established in Scarborough in 1849. In this photograph of about 1905, two white-coated assistants stand by their handcarts ready to deliver grocery orders around the village. Wallis & Blakeley's went out of business in the General Strike of 1926, and was subsequently run by Thornton's and by Rowntrees for a number of years. It is now the very popular Yew Tree Café in the heart of the village.

Inset: A Wallis & Blakeley advertisement of 1925.

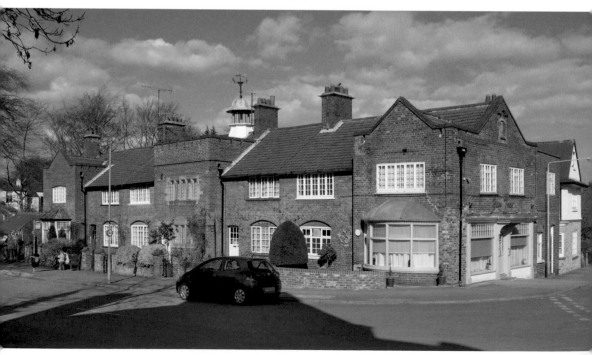

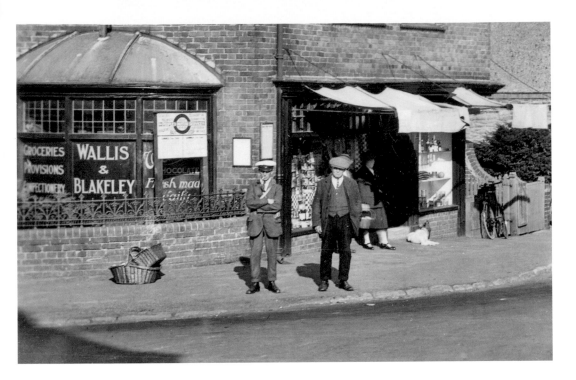

Changes on High Street

A detail from another photograph of Wallis & Blakeley's shop reveals the sign in front of the window for 'The Peoples Motor Service' and the destinations served – Scalby, Newby, Cloughton, Burniston, Hackness and Hayburn Wyke. The gentleman in the white-topped cap may be a bus conductor or he might be a local milkman pausing to pass the time of day! Below, Thornton's, who took over the business at Yew Court Terrace, appear to be bursting at the seams with stock spilling out onto the pavement.

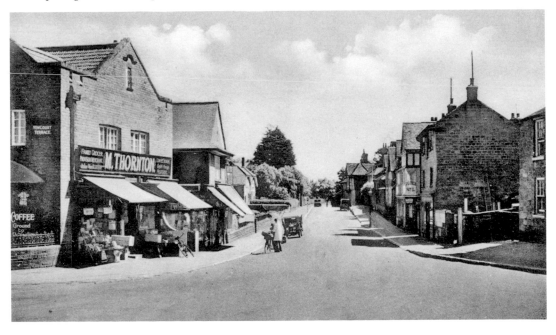

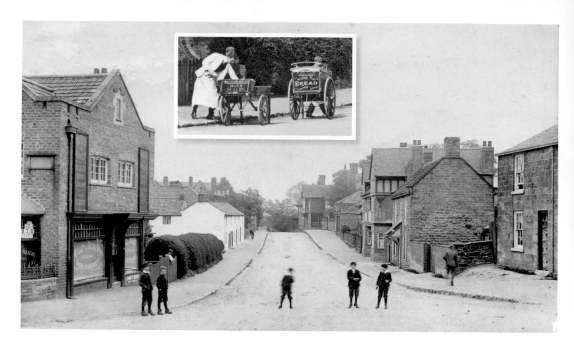

Changes on High Street

In this view down High Street in 1904, Wallis & Blakeley's shop is on the left and beyond the hedge a row of whitewashed cottages (see opposite). The second building on the right was the original Plough Inn, which had moved into the new half-timbered building next door in the 1890s.

Inset: A detail from another Wallis & Blakeley photograph, of about 1912, shows two handcarts being readied to deliver groceries. The first has 'Wallis & Blakeley, Branch, Scalby' on the back, and the other the rather intriguing 'Machine Made Bread Delivered Daily'.

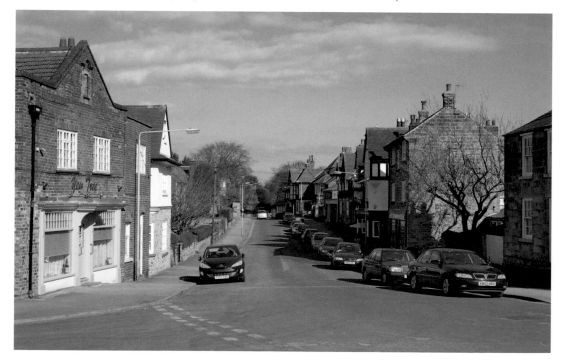

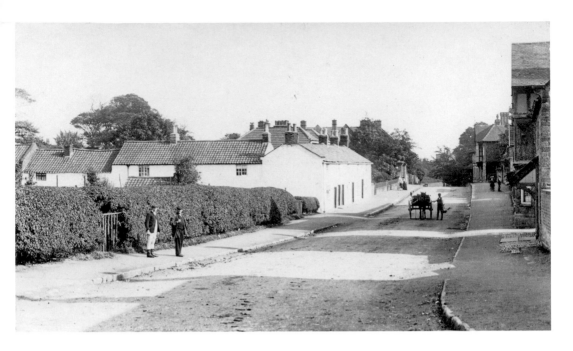

High Street: New Houses for Old

These whitewashed cottages stood nearly opposite the Plough Inn. The whole of the area, on the left, is now occupied by houses, in one of these Max Jaffa, a well-known violinist, and his wife, Jean Grayson, lived. The pair of cottages in the lower photograph replaced the whitewashed cottages by 1905, and the picture provides a delightful snapshot of the slow pace of village life a hundred years ago. Bicycles have evolved since the picture was taken and wheelbarrows have lost their appeal since they were made of sheet metal!

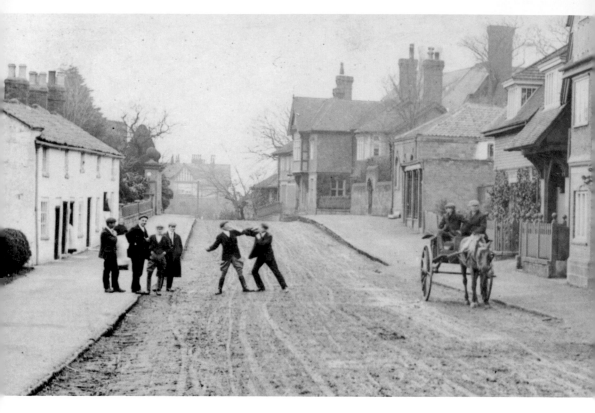

Punch-up at the Plough Hotel

A 'punch-up' appears to be taking place opposite the Plough Inn, but the bystanders appear to be taking more interest in the photographer than the 'fight'. The original Plough Inn (page 60) was to the right, but it was moved to the mock-Tudor edifice built next door. The name was soon changed to Plough Hotel to reflect the increasing popularity of Scalby as a high class residential and tourist area. Mr John William Crosier was the proprietor of the hotel in the 1930s, and produced this entertaining Free Pass.

PLEASE NOTE.

Our business was established a few years ago. We have been pleasing and displeasing people ever since. We have made money and lost money. We have been cussed and discussed, knocked about, talked about, lied to, held up, robbed, etc., to the end of the chapter. The only reason we are staying in the business is to see what the hell is going to happen next.

WILL the Lady and Gentleman who stole two glasses on Saturday, kindly hand their names over the Counter, when they will be presented with four more to make up the half-dozen.

THE LANDLORD'S LATEST.

Angry words they do no good,
Blows are struck in blindness;
Things would be better understood
If spoken but in kindness.

The Modern Press, Clayton Works, Croydon.

All are welcome

at the

Plough Hotel

SCALBY, SCARBORO'

TEL. 163.

Electric Light

Central Heating

FULLY LICENSED

•

BED & BREAKFAST

TEAS

•

Proprietor - - J. W. CROSIER

Free Pass

This Pass is good on all Railroads provided that the bearer walks, carries his own luggage, swims all rivers, and stops for all drinks and smokes at

— THE —

PLOUGH HOTEL

SCALBY

2½ miles from Scarborough.

Proprietor : J. W. CROSIER

NOTICE.—A man is engaged in the Yard to do all the Cursing, Swearing, and Bad Language that is required in the Establishment. A dog is kept to do all the Barking. Our Potman (or Chucker-out) has won 90 prizes, and is an excellent shot with a revolver. An Undertaker calls every morning for orders.

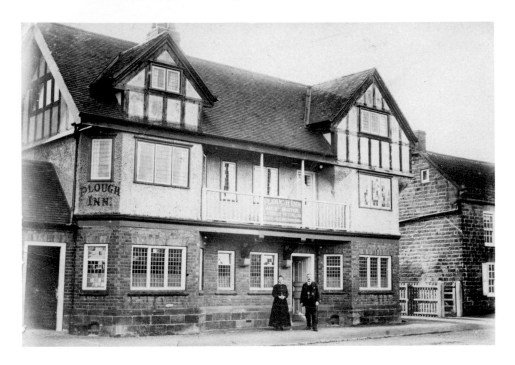

The Plough Inn

The Plough Inn appears to have changed very little since it was in the occupation of James Henry Morton and his wife, pictured here in about 1910. Previous victuallers had been Thomas Gell in 1905 and William Duck in 1890. Beyond The Plough, as it is now called, is the Village Stores, formerly the original Plough Inn and later Lynn's confectionery shop, a building that has undergone an increase in height and the addition of an extra storey compared with the old photograph.

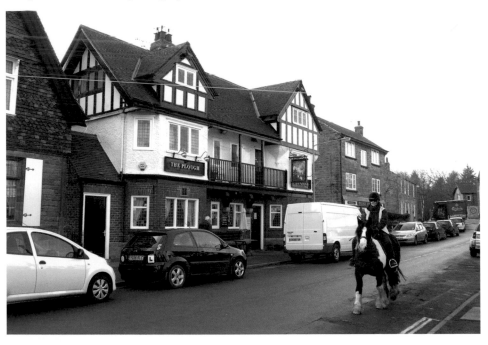

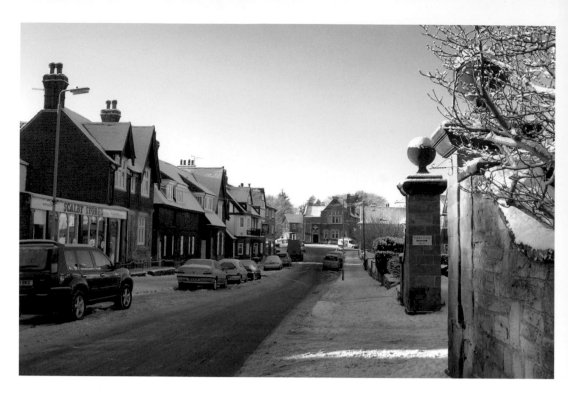

High Street: In the Bleak Midwinter

The winter of 2010/11 may have seemed long and severe to those who do not remember the bad winters of 1947 or 1963, but as can be seen on this pair of photographs there was a much greater depth of snow in Scalby in 1925. On the left, Scalby Stores continues to supply fresh foods, newspapers and books to the local community. It had been two shops at the time the old photograph was taken and the separate doorways can be seen at each end of the shop windows.

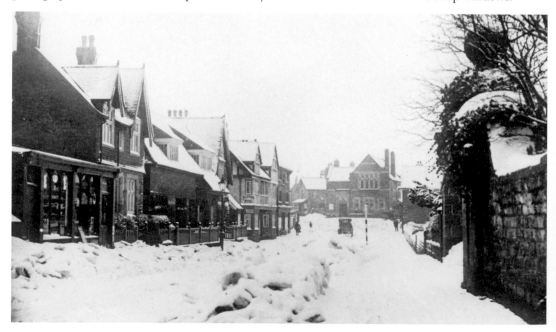

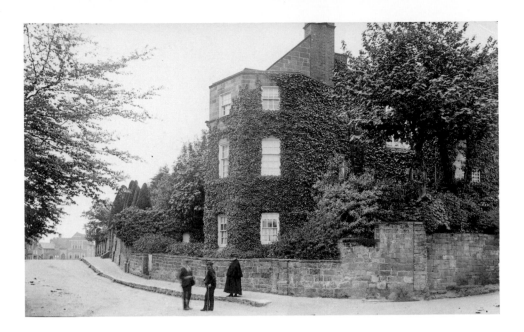

Yew Court at the Crossroads

High Street from the crossroads on Scalby Road in 1904. On the right is Yew Court, one of the best-known houses in the village. In 1829, it was described as 'an irregular building presenting an angular projection at the east end and gardens of the old style of decoration with Yew-trees cut into fantastic shapes and in general suited to the appearance of the house which is grotesque and singular.' It was built in 1742 for a Captain Ians, and in 1761, His Royal Highness the Duke of York was entertained here by the then owner, Ralph Betson, the Scarborough Town Clerk. The artist Atkinson Grimshaw, of moonlit scene fame, painted the house and garden in 1887. It was later bought by William Catlin, son of Will Catlin, who was famous for his Pierrots in Scarborough. After he died in 1962 it was converted into flats.

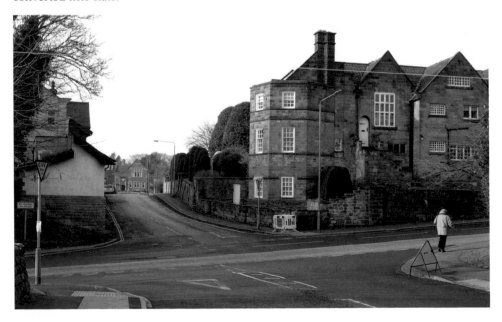

Scalby Road from the Crossroads Looking South

Looking south down Scalby Road in about 1910 there was not a single building on the left until the houses at the north end of Newby came into view. Nearer the camera, at the bottom of the hill, Newby Bridge had yet to be rebuilt for the second time, and the road straightened, in the 1950s (see pages 5–7). On the left there are now tennis courts, bowling greens, the Scalby Parish Hall, built in 1922, and the former Scalby Urban District Council offices built in 1938.

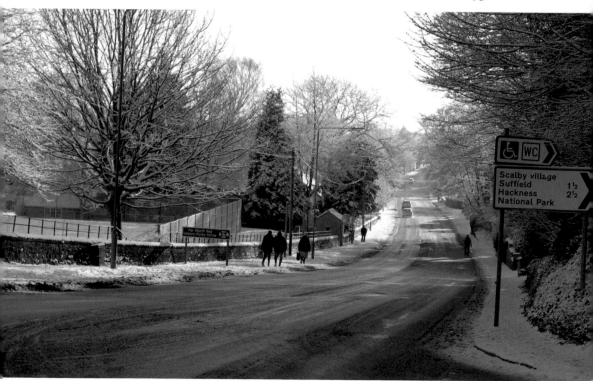

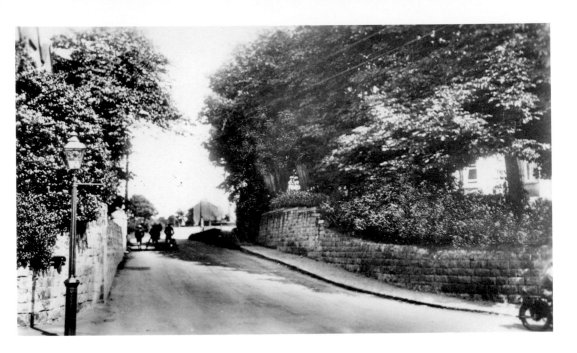

Scalby Road from the Crossroads Looking North

Looking north up Scalby Road, this narrow thoroughfare was originally known as Back Street, which perhaps indicates its lack of importance over 100 years ago. Now it is part of the very busy A171 to Whitby and Middlesbrough, necessitating a central refuge for pedestrians crossing between the old (west) side of Scalby to the newer (east) side. The old road has been considerably widened to accommodate the vastly increased road traffic that is absent from this photograph because of the severe winter weather of 2010/11.

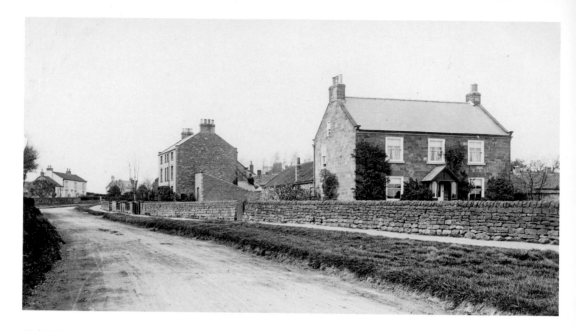

Field Close Farm

Field Close Farm (see recent photograph opposite) on Back Street, marked on the OS plan of 1852, was part of a small group of dwellings that at that time were distinctly separate from Scalby village, and are situated opposite the end of Stony Lane, which connects through to North Street (pages 52–53). The lower photograph illustrates an unidentified Scalby farmyard in about 1906 – a delightfully picturesque and rustic scene, a far cry from many of the highly mechanised farms of the present day.

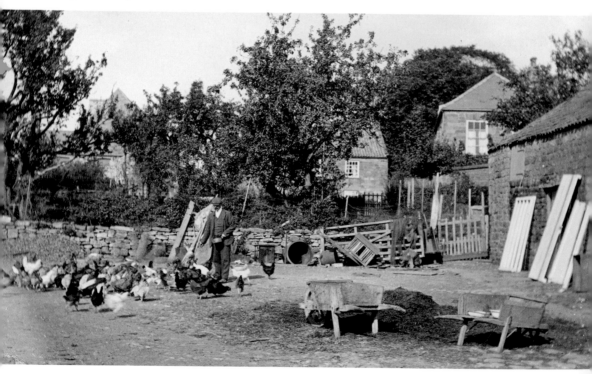

North of Field Close Farm

Field Close Farm now has a ground floor extension with additional windows and a pillared porch-way, replacing the original wooden structure (see opposite), and contains the Daisy Tea Rooms. Beyond the farmhouse are the group of buildings opposite the end of Stony Lane mentioned on the previous page. On the left side beyond the old houses, the fields are now the site of recent housing developments that extend all the way up to Barmoor Lane, the present northerly extent of Scalby village.

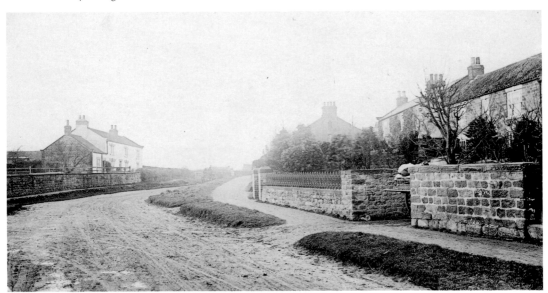

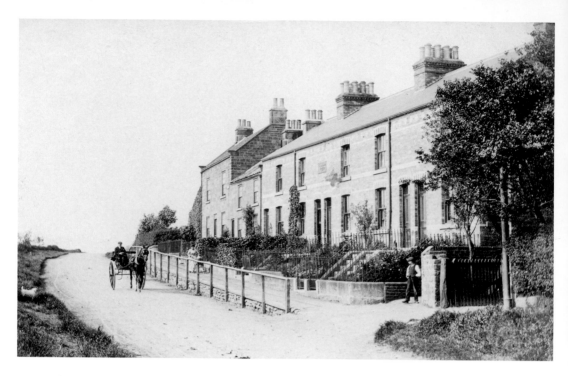

Jubilee Terrace, Scalby Road, from the South

It is easy to date Jubilee Terrace as many new streets around the country were so named when they were built in 1887, the year Queen Victoria celebrated fifty years on the throne. This is confirmed by the plaque on the front of the building. The photograph is taken from a postcard dated 1909, and the message, written by a visitor staying at No. 3 Jubilee Terrace, reads, 'Everything looks so nice and fresh, all we want is some fine weather then we shall be first class.'

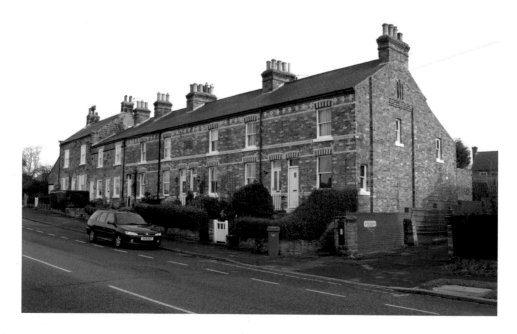

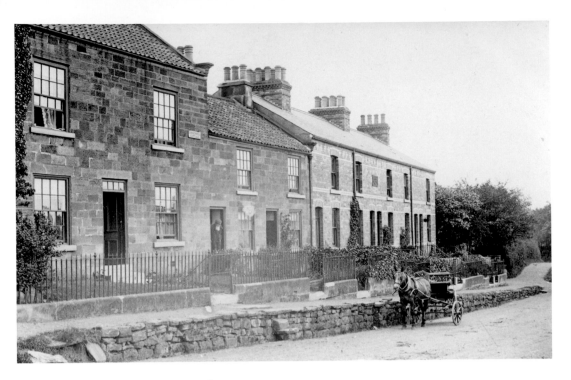

Camberwell Cottage and Jubilee Terrace

At the north end of Jubilee Terrace there are two earlier stone-built houses, the nearest to the camera being Camberwell Cottage. In 1894, Mrs Estill provided accommodation for visitors at Camberwell Cottage consisting of three bedrooms and two sitting rooms. Two structural changes here are of note – the change in height of the smaller stone cottage to match the height of the roof of Jubilee Terrace, and the change in the height of the road relative to the front gateway of Camberwell Cottage.

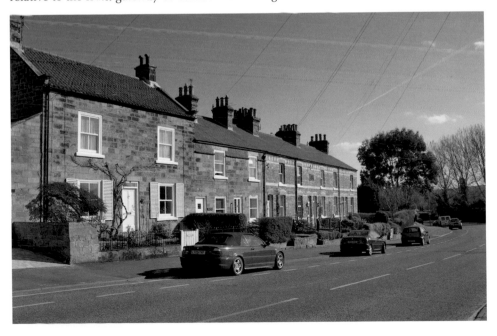

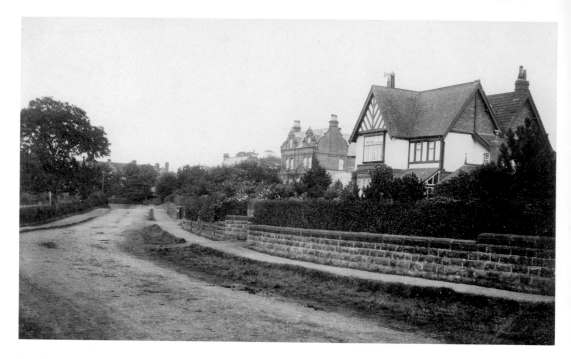

Station Road: The Changing Seasons

East of the crossroads all of the houses on the north side of Station Road, as far as the station, were built in the 1880s–1890s, in response to the opening of the Scarborough & Whitby Railway in 1885. Many of the houses built here were substantial properties with extensive gardens and the development included the new residential streets of The Park, and East and West Park Roads. Both photographs were taken looking west along Station Road with the same herringbone gable end appearing on both photographs.

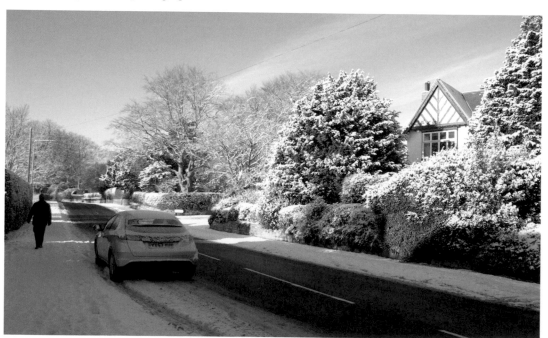

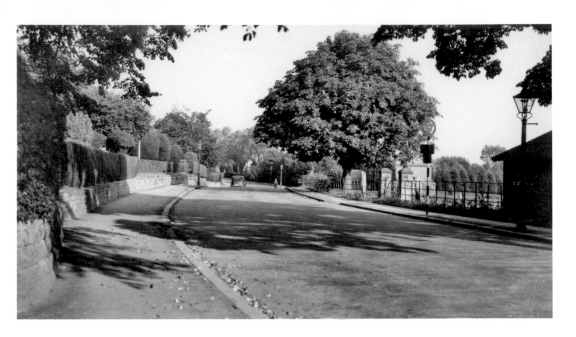

Station Road from the West

On the right, the stone pillars mark the entrance to what, in the author's early memory, was a field full of rather large and inquisitive cows. It is now the site of the tennis courts and bowling greens. The Scalby & Newby Bowling Club was founded in 1930, but ladies were not admitted as full playing members until 1950, and from then it grew from strength to strength! Note the large gas streetlamp on the right – these were often lit individually by a lamplighter, who walked or cycled round the streets as dusk fell in the evening.

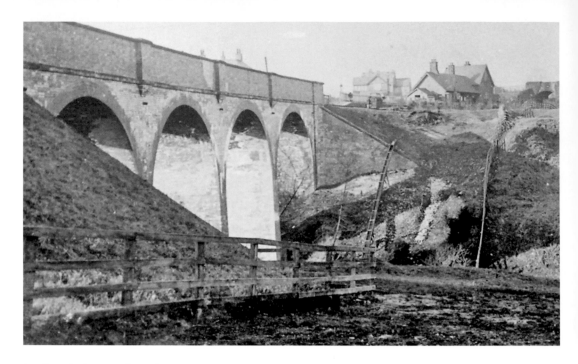

Scalby Viaduct and Station

The Scarborough & Whitby Railway was opened in July 1885, and the first of the eight stations on the line was at Scalby, which was approached over a four-arch, brick-built viaduct that still stands. The early photograph, taken in about 1905, gives a clear view of the station buildings, on the right, whereas the present day view is largely obscured by trees, even in winter. The line closed in 1965 and the track-bed is now an interesting and attractive walkway, and part of the National Cycle Network, right through to Whitby.

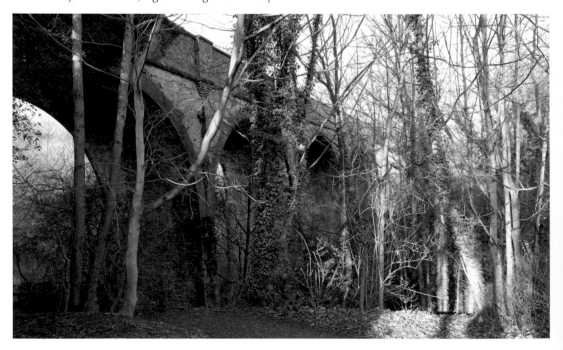

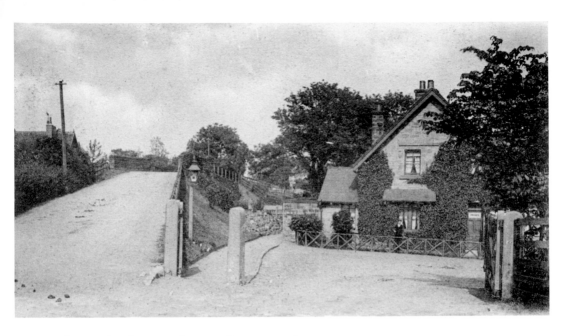

Scalby Station from Station Road in 1904 and 2011

At Scalby, Station Road used to climb up over a very picturesque hump-backed bridge (see pages 78–79) in order to cross over the railway. The old view shows the entrance to the station yard and the stationmaster's house, with its rustic fencing and ivy-covered walls, next to the bridge. The station and bridge were demolished in 1974 to make way for the new housing development of Chichester Close, and it is now hard to visualise that there ever was a station here. On the right an original gatepost still survives.

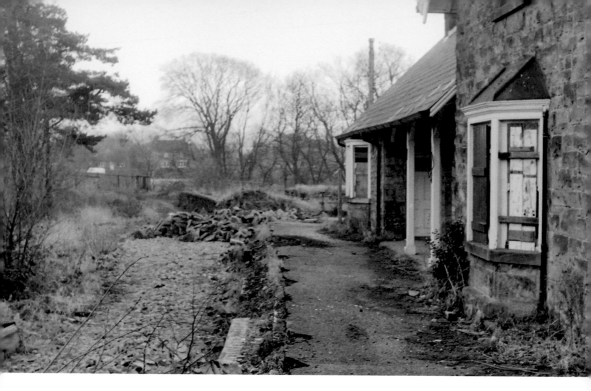

All Change at Scalby Station

Scalby station closed on 28 February 1953 and for a time the stationmaster's house was used as a camping cottage. It also housed a retired stationmaster and his family for a few years, but the end came in 1974 when contractors arrived to demolish the building completely. In the upper photograph work had just started with the platform facing being removed stone by stone. Looking south the new buildings of Chichester Close almost follow the line of the original buildings towards the viaduct.

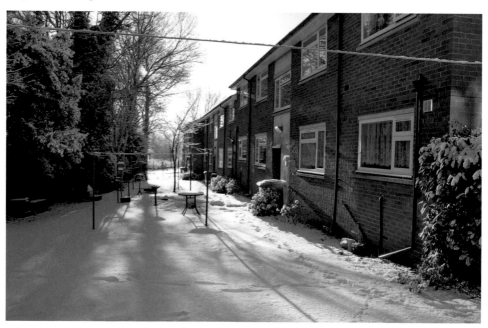

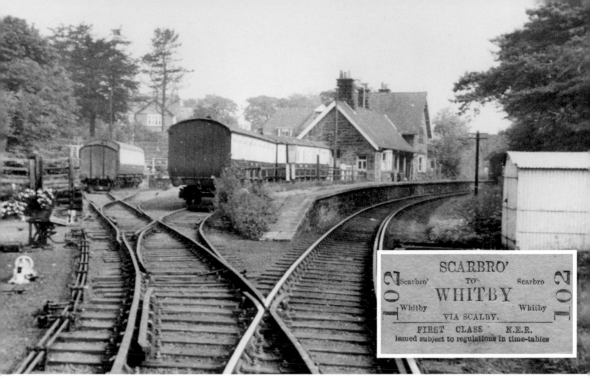

SCARBRO'

Scarbro' **TO** Scarbro

WHITBY

Whitby Whitby

VIA SCALBY.

FIRST CLASS N.E.R.

Issued subject to regulations in time-tables

Carry on Camping at Scalby Station

Camping coaches were reintroduced by British Railways in the 1950s and were painted in a pleasant cream and green livery. They were very popular with most holidaymakers who had to buy return tickets from their home town to the camping coach station. The lower photograph was taken on the last day of passenger traffic on the line, 6 March 1965, from the 'Whitby Moors Rail Tour' as it passed through Scalby (see page 81).

Inset: A First Class ticket 'via Scalby' dated 10 September 1885, only two months after the line opened.

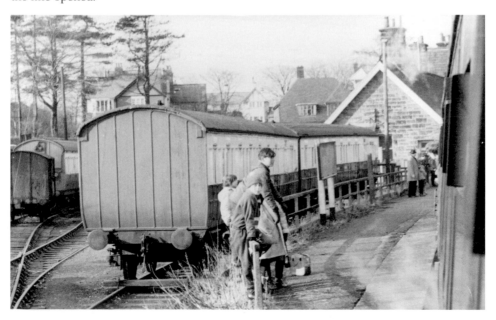

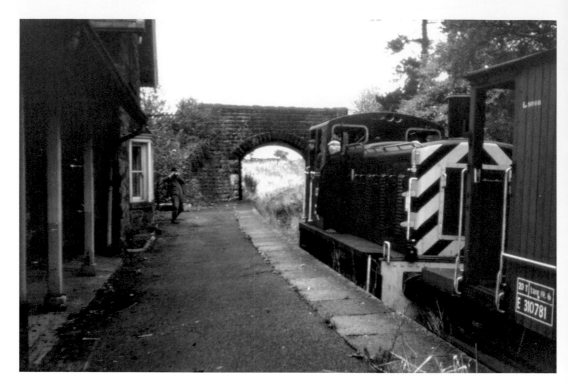

The End of the Bridge at Scalby Station

The line closed in 1965, and in October 1967, after the decision to lift the line had been taken, this train, consisting of two brake vans and a diesel shunter, traversed the line. It carried the contractors who were going to tender for the redundant assets of the line including the ballast, sleepers, and rails. It was the very last train to run on the line and all the materials had been removed within a year. The railway cutting north of the station was filled in and the bridge demolished down to the new road level in 1974.

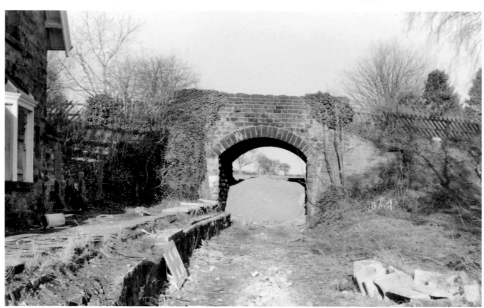

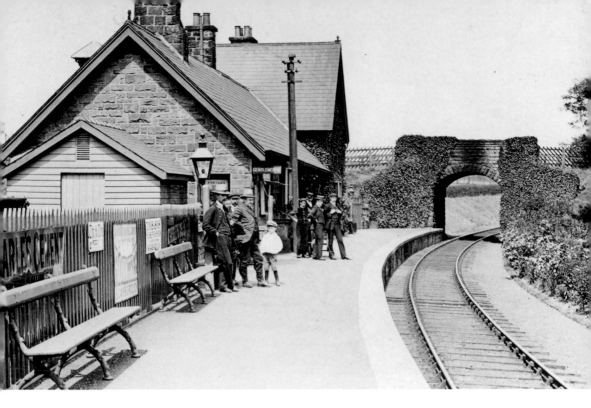

Calling a Halt at Scalby Station

There is no doubt that Scalby station was a very picturesque and attractive place. The building was commenced in January 1885, when it was estimated that it would take two or three months to complete. Like the other stone-built stations on the S&WR, it was well-constructed – some of the walls were 18 inches thick and it was sad to see it being demolished in 1974 (below). It had served the inhabitants of Scalby well during the sixty-eight years that the station was open (see *Scarborough & Whitby Railway Through Time*).

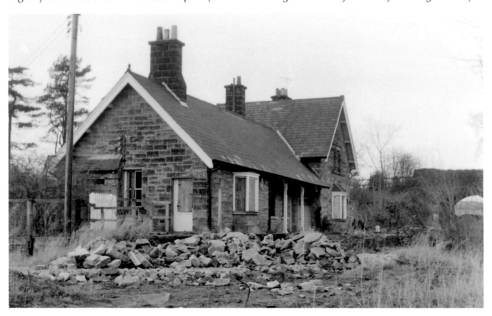

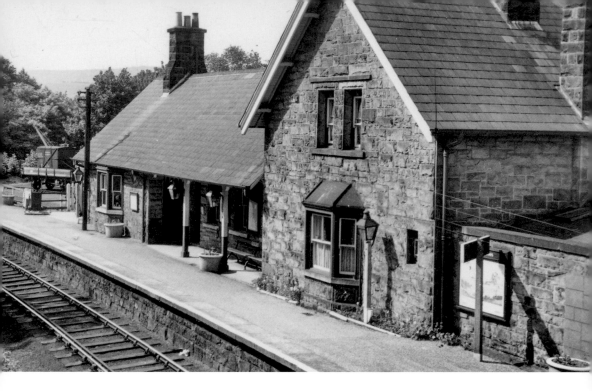

Scalby Station: A View from the Bridge

The hump-backed bridge at the north end of the station provided a good vantage point for photographers. Above, the station is seen prior to closure looking clean and tidy with paraffin lamps along the platform, a poster on the wall, and a wagon in the goods yard. Below, the contractors have started their demolition work and the roof slates have been removed. Shortly before the contractors started work, a large quantity of paperwork was removed from the loft, some of it dating back to the 1880s.

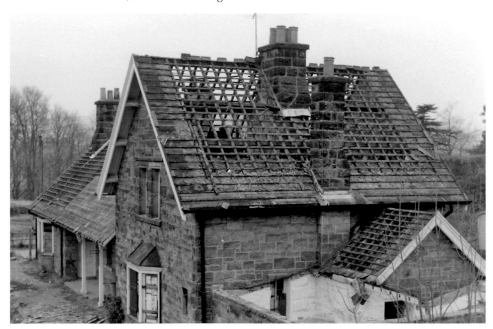

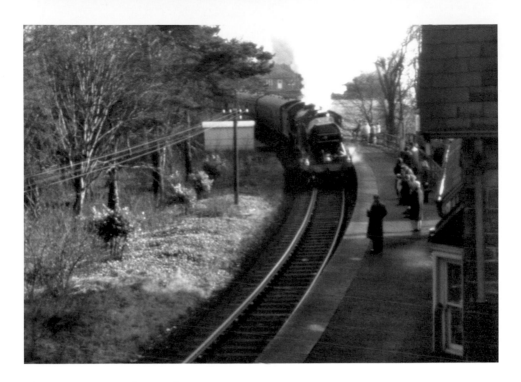

The Last Day at Scalby Station

This double-headed, steam-hauled special excursion ran through the station on the last day of passenger traffic (see page 77). The hump-backed bridge provided, for the last time, a fine vantage point to see the train approaching from Scarborough and, after a quick dash to the other side of the bridge, to see it disappearing out of sight and into history. The land on the north side of the bridge, having been levelled, now forms the back gardens of the houses on the east side of Lancaster Way.

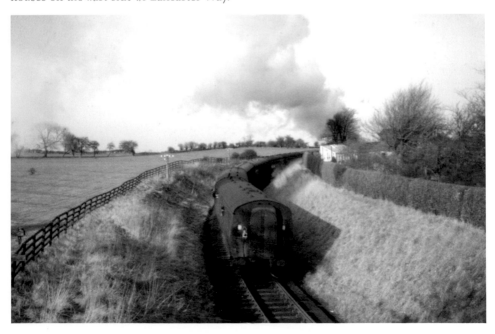

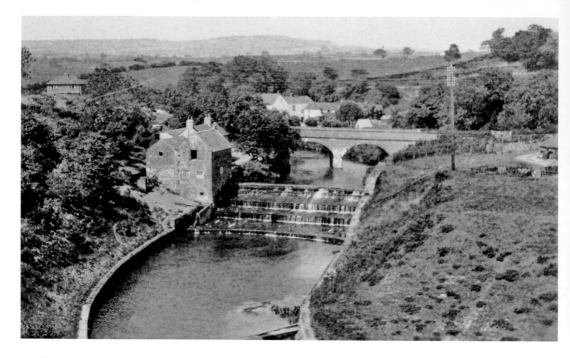

Scalby Beck and Burniston Road Bridge

Burniston Road Bridge crosses Scalby Beck about half a mile from the sea at Scalby Ness. There were four water mills on the stretch of Scalby Beck between Newby Bridge (see page 5) and the sea. Beyond the bridge in the top picture is Scalby Bridge Mill, which was converted into a Youth Hostel, but this has now closed and at the time of writing was for sale. On this side of the bridge Newby Mill was next to the weir. Further upstream there was High Mill and near to the beach was Scalby Low Mill (see page 89).

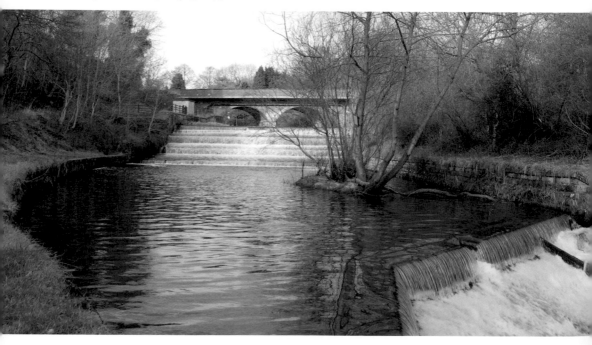

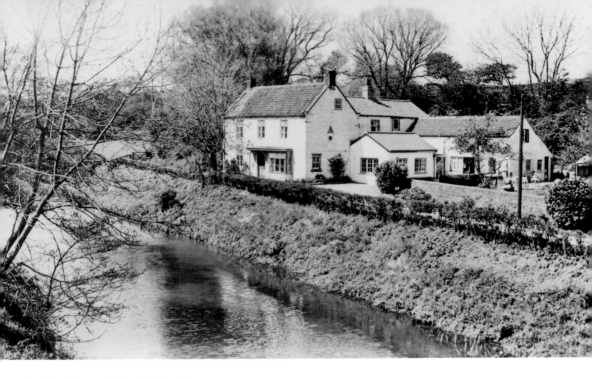

Scarborough Youth Hostel

Very little is known about Scalby Bridge Mill and its history, but it is thought to date from about 1600. By the nineteenth century, there were a total of five water mills in Scalby within a short distance of each other. The buildings here were considerably extended and altered after it became Scarborough Youth Hostel in 1935, but it closed in 2010. It is in an idyllic location next to Scalby Beck, where the wooded location is a rich haunt of wildlife and there is a delightful riverside walk down to Scalby Mills.

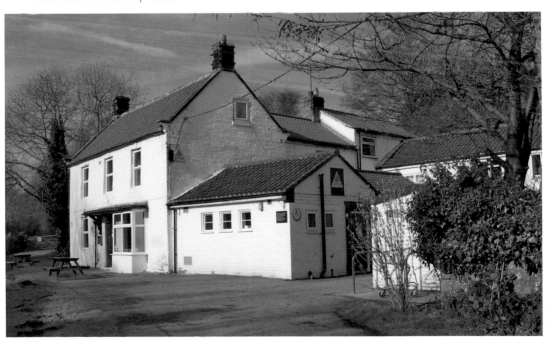

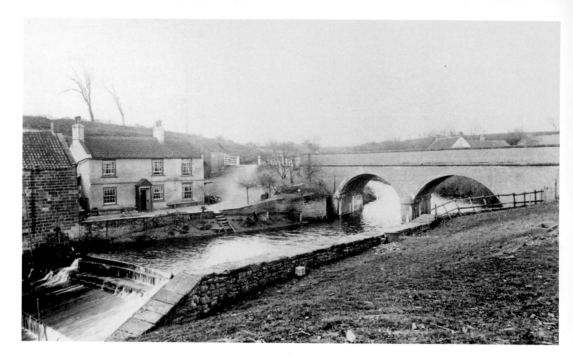

Newby Mill and Weir

Newby Mill was run by the Flinton family for many years and the whitewashed house was the home of Thomas Flinton, a corn and flour merchant in 1890. In the 1934 *Directory*, Israel G. Flinton was recorded at Newby Mill, but the earliest record dates to 1855, when William Flinton was the miller here. The photograph of the weir was taken in about 1908, and the milling machinery was housed in the building on the left. The mill wheel could still be seen after it ceased to work during the First World War.

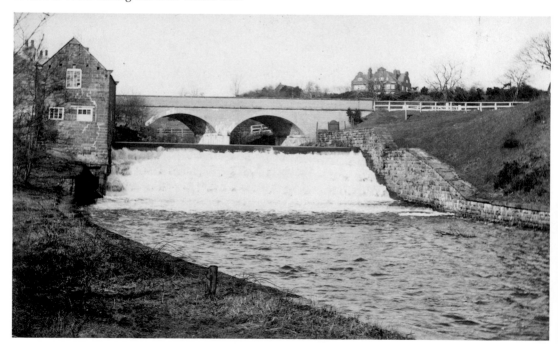

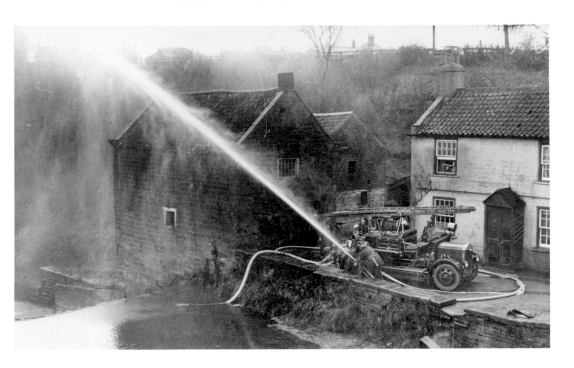

Scalby Fire Brigade at Newby Mill

Scalby Volunteer Fire Brigade (see pages 26–27) testing their equipment in a quite spectacular fashion in front of Newby Mill. As a corn and flour merchant for the area, Thomas Flinton received considerable quantities of Barley, Maize and Oats from places as far away as Malton via the railway. Postcards dated in the late 1880s record this traffic that had to be offloaded from the railway wagons in Scalby station goods yard, and delivered by horse and cart to Newby Mill, which was demolished in about 1950.

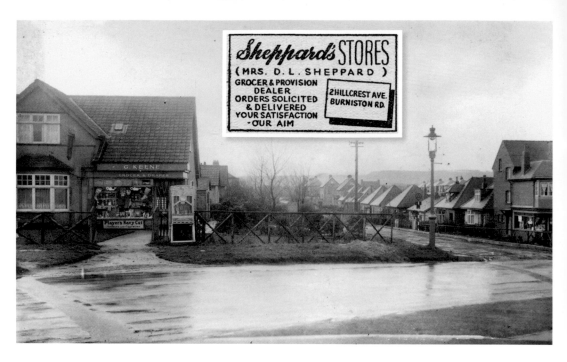

Burniston Road & Hillcrest Avenue

There were local shops on opposite corners at the end of Hillcrest Avenue but, like so many over the last fifty years, both have closed and reverted to residential use. On the left, G. Keene ran a grocery and drapery business and on the right Sheppard's Stores is recorded here in 1952.

Inset: an advert for Sheppard's Stores in 1952.

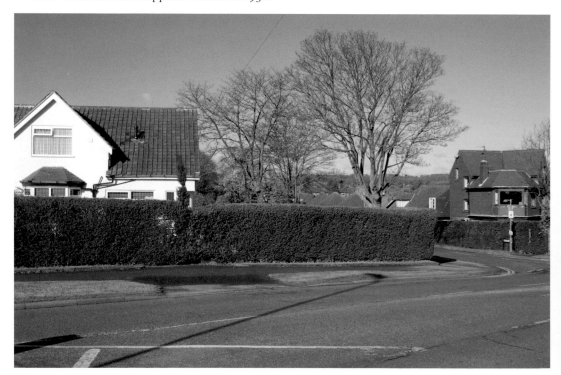

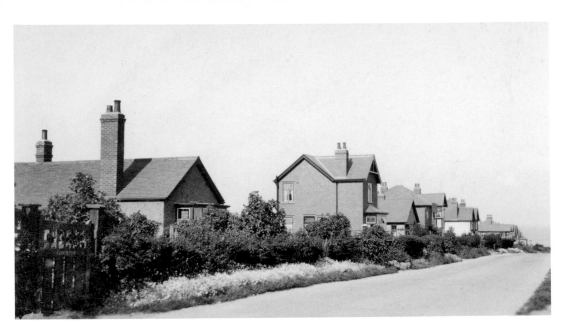

Nothing Odd on Scalby Mills Road

Scalby Mills Road is a street without odd numbers as all the houses on the left side have even numbers and on the right the land is occupied by the North Cliff Golf Course. The 1966 handbook for the club stated that the yearly fees for gentlemen were £10 10s (£10.50). The course opened here in 1928 and the fairway for the second hole runs alongside the full length of the road. A new development on Scalby Mills Road, the Captain's View apartments, can be seen from the green at the second hole.

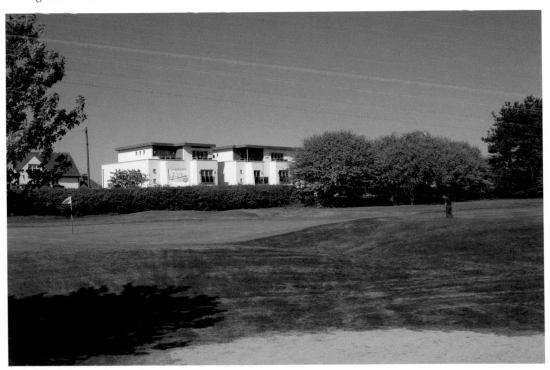

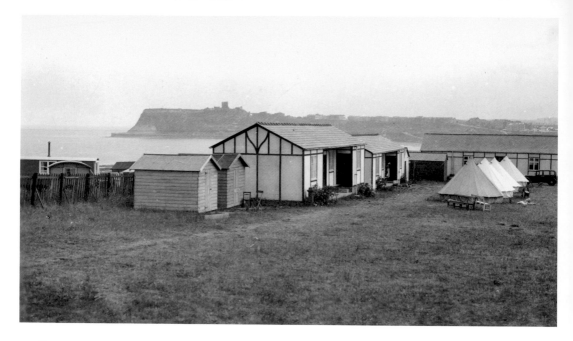

Scalby Mills Holiday Camp

Scalby Mills Holiday Camp was situated on the cliff, near the end of Scalby Mills Road, overlooking the North Bay. In a Scarborough guide of 1932, it was promoted as the Mixed Holiday Camp, Scalby Mills, and advertised that it was in an 'ideal situation near to all North Side attractions'. Accommodation was provided in bungalows at £2 7s 6d (£2.37) or tents at £2 2s (£2.10). Later, it became very popular as Colly's Cosy Camp, until it was demolished to make way for a new holiday home development.

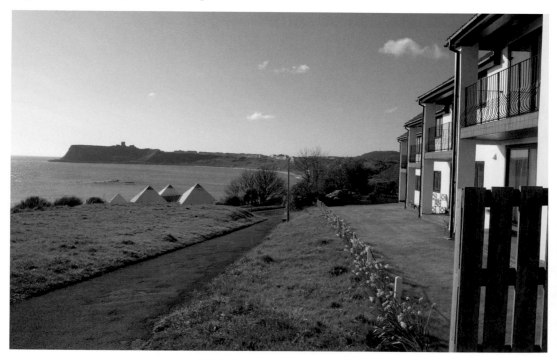

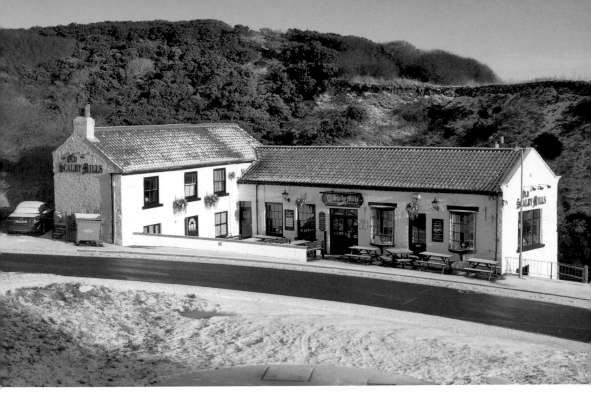

Scalby Mills Hotel

This was once the site of Scalby Low Mill, but it was so often damaged by flooding that it became disused and burnt down in 1821. However, a *Directory* of 1823 recorded J. Pearson as victualler and corn miller at Scalby Mills, and by 1850 the new building had become a hotel as the grounds had already become popular for its Strawberry Garden with visitors seeking the quieter side of Scarborough. The area in the foreground is now the site of a giant underground pumping station for Scarborough sewage.

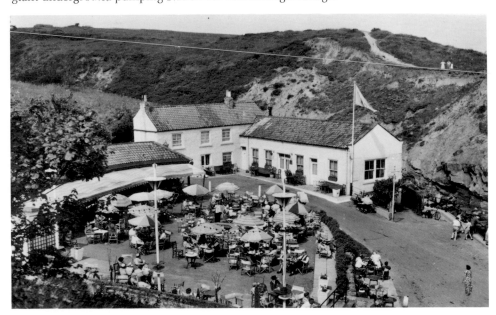

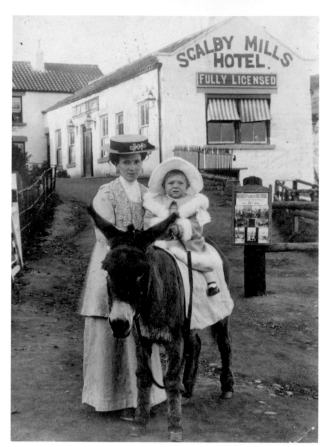

In the picture at Scalby Mills

Marshall's *Picturesque Guide to Scarborough* of 1889 records that, 'The celebrated Scalby Cakes, tea, wines and other refreshments are served in the arbours or on the lawn shaded by trees and shrubberies. It is a favourite rendezvous for children on donkeys and their friends. Swings and outdoor games are here provided.' Ladies also enjoyed the donkeys (see front cover) and rode side-saddle – a necessity in the days of long skirts and voluminous petticoats! In the top view a display of postcards by an enterprising photographer who has found a ready market in the holidaymakers on their donkeys. The sign above the cards in the photograph reads, 'Portraits printed on postcards, with a view of Scalby Mills, 3/- (15p) a dozen.'

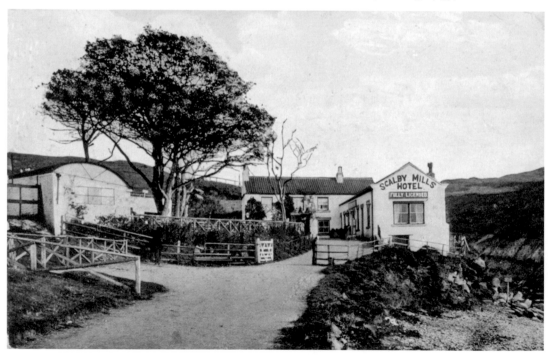

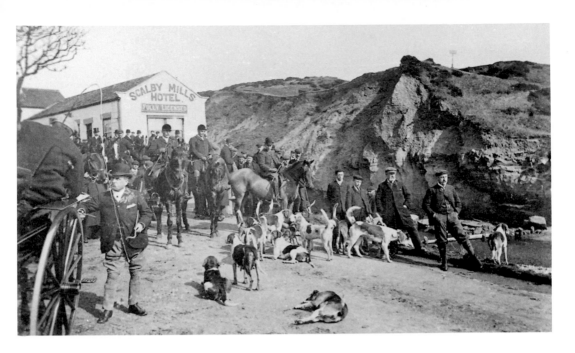

Scalby Mills: Some Unusual Visitors

Scalby Mills occasionally had some strange visitors – the local hunts were more usually seen in the open countryside, not down at the beach! Below, the most unusual visitor here must have been the decommissioned First World War Royal Navy 'G' class submarine that was being towed up to Sunderland for scrap when she broke free of her tow-rope and ran ashore at Scalby Mills in December 1921. In the foreground, a brewery lorry delivers barrels of beer to the pub that still serves real ale!

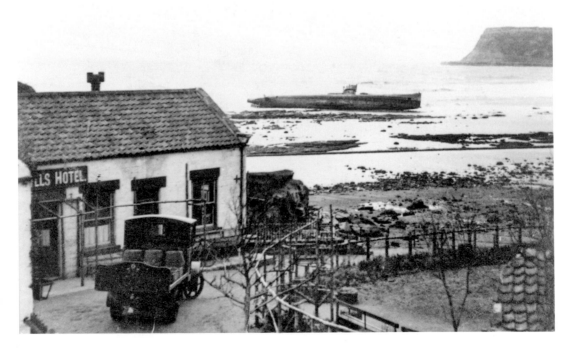

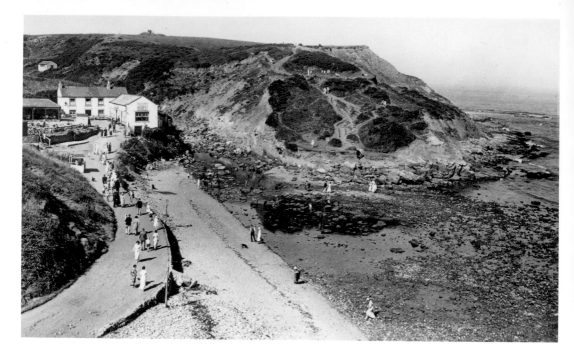

A Changing Scene at Scalby Mills

The early photograph was taken from Monkey Island (see opposite) and shows the Scalby Mills Hotel in its seaside setting in about 1936, before the area was developed and the North Bay promenade extended all the way to Scalby Beck. A substantial concrete footbridge now provides access to the cliff path, part of the Cleveland Way that goes all the way to Whitby and beyond. Old Scalby Mills, in the distance on the left in the lower photograph, is now dominated by the Sea Life Centre with its bulging promenade.

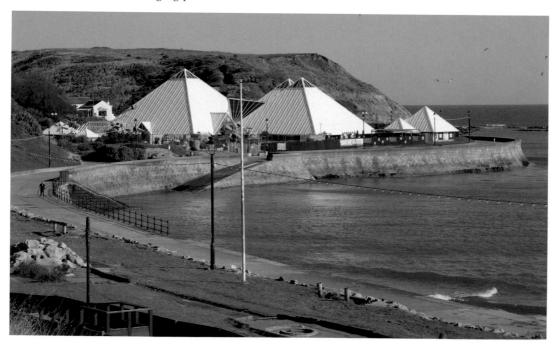

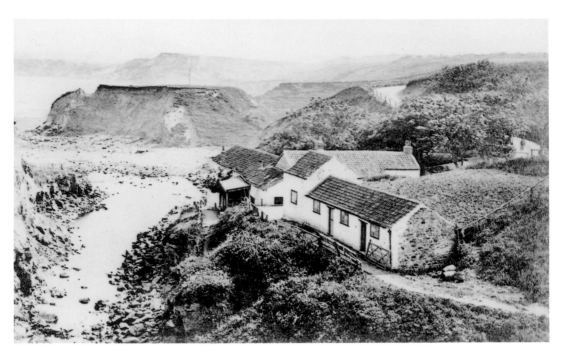

Monkey Island to Sea Life Centre

Beyond the Scalby Mills Hotel, on the left, Monkey Island had been large enough to play football on, as seen in this view dating back to about 1880. By the 1950s, it was a conical hill of boulder clay that was rapidly eroding – it was a popular playground for children who used to race to the top to be 'king of the castle', but it was a dangerous game as at the top there was a sheer drop on the seaward side! Monkey Island has long since vanished and in its place are the pyramidal shapes of the Sea Life Centre.

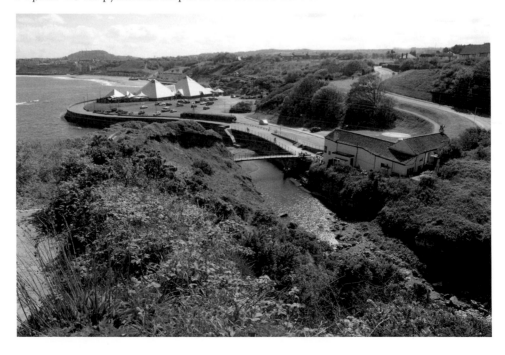

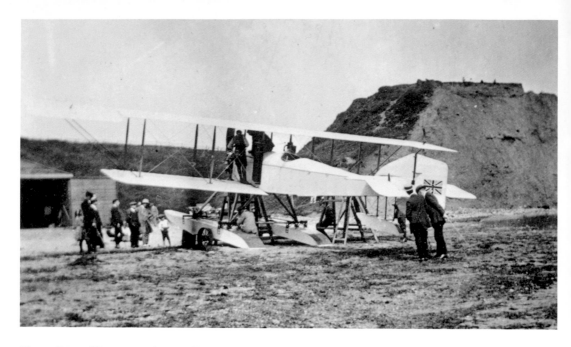

Those 'Magnificent Men' at Scalby Mills

At the top of the beach, near to Monkey Island (on the right), there was a Royal Naval Air Service station, with a large hangar that housed a Blackburn Type L seaplane. It had been built in Leeds to fly in the Daily Mail Round Britain Air Race in 1914. However, after the outbreak of hostilities in 1914, it carried out patrols on the Yorkshire coast. Early in 1915, it crashed into the top of Speeton Cliffs. The close-up, below, gives some idea of its size – wingspan 49.5 feet, length 32.5 feet, height 12.5 feet, with a maximum speed 81 mph.

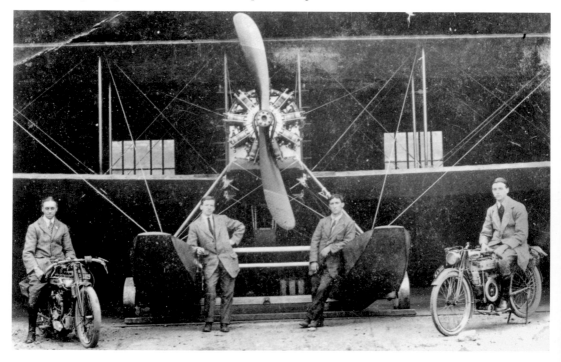

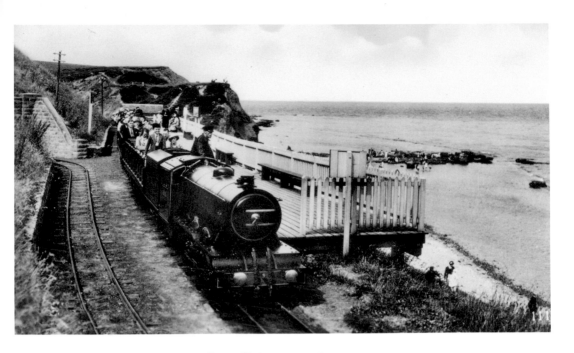

The North Bay Railway at Scalby Mills in 1938 and 2011

The North Bay Railway is one of the oldest seaside miniature railways in the country. It was opened on 23 May 1931 and celebrates its 80th year of operation this year (2011). The first engine was No. 31 *Neptune* (below) and this was followed in 1932 by No. 32 *Triton* (above). Both were steam outline, diesel-powered engines built by Hudswell Clarke of Leeds. The track gauge is 20 inches and the length of the line about ⅞ of a mile, running from Peasholm Station to Scalby Mills Station.

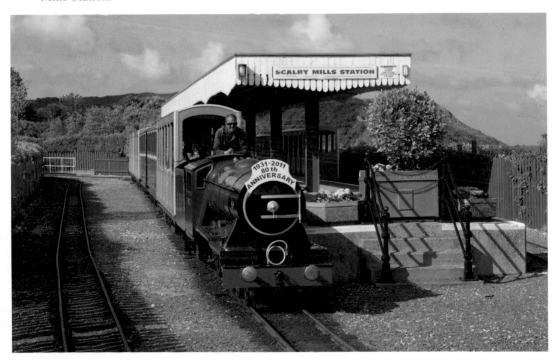

North Bay Railway: A Line to the Future
Neptune, on its way to Scalby Mills, waits for *Triton* and its train to pass in the loop at Beach Station. Originally opened by the old Scarborough Corporation, the operation of the railway has recently been handed over to the North Bay Railway Company and the attraction has been given a new lease of life with two new locomotives, covered, all-weather carriages, and a turntable at Scalby Mills. It continues to delight and enthral children into the twenty-first century.

Bibliography

The following sources have been consulted in the preparation of this book: *The Scarborough Tour in 1803*, W. Hutton, 1804; *Historical Sketches of Scalby Burniston and Cloughton*, John Cole, 1829; *B. H. Gillbanks & Co's Directory & Gazetteer of Scarborough...*, 1855; *Marshall's Picturesque Guide to Scarborough*, 1889; *History, Topography and Directory of North Yorkshire*, T. Bulmer, 1890; *Official Guide to the Scarborough & Whitby Railway*, Alex Wilson, 1894 & 1897; *The Scarborough Gazette Directory*, 1905; *W. H. Smith & Sons Revised Directory of Scarborough...*, 1932; *Revised Scarborough and District Directory*, Saint Nicholas Press, 1934; *Kelly's Directory of Scarborough*, 2nd edition, 1952; *Old Scalby*, J. D. Tickle, 1957 (a series of articles in the Scarborough Mercury); *Official Handbook*, The North Cliff Golf Club, 1966; *Kelly's Directory of Scarborough*, 17th edition, 1976; *Scalby and the Village Trust – Ten years of progress 1967–1977*; *Scalby Parish Church a Brief History and Guide*, D. E. Richardson, 1983; *A Guide to Newby & Scalby: Celebrating the Silver Jubilee of The Scalby Village Trust*, 1992.